COOL SHOPS LONDON

teNeues

Editor:	Llorenç Bonet
Photography:	Roger Casas
Introduction:	Llorenç Bonet
Copy editing:	Alessandro Orsi
Layout & Pre-press:	Cris Tarradas Dulcet
Translations:	Bill Bain (English), Susanne Engler (German)
	Marion Westerhoff (French), Sara Tonelli (Italian)

Produced by Loft Publications
www.loftpublications.com

Published by teNeues Publishing Group

teNeues Publishing Company
16 West 22nd Street, New York, NY 10010, USA
Tel.: 001-212-627-9090, Fax: 001-212-627-9511

teNeues Book Division
Kaistraße 18, 40221 Düsseldorf, Germany
Tel.: 0049-(0)211-994597-0, Fax: 0049-(0)211-994597-40

teNeues Publishing UK Ltd.
P.O. Box 402, West Byfleet, KT14 7ZF, Great Britain
Tel.: 0044-1932-403509, Fax: 0044-1932-403514

teNeues France S.A.R.L.
4, rue de Valence, 75005 Paris, France
Tel.: 0033-1-55 76 62 05, Fax: 0033-1-55 76 64 19

teNeues Iberica S.L.
Pso. Juan de la Encina 2-48, Urb. Club de Campo
28700 S.S.R.R., Madrid, Spain
Tel./Fax: 0034-91-659 58 76

www.teneues.com

ISBN-10:	3-8327-9038-1
ISBN-13:	978-3-8327-9038-7

© 2005 teNeues Verlag GmbH + Co. KG, Kempen

Printed in Spain

Bibliographic information published by Die Deutsche
Bibliothek. Die Deutsche Bibliothek lists this
publication in the Deutsche Nationalbibliografie;
detailed bibliographic data is available in the Internet
at http://dnb.ddb.de.

Contents

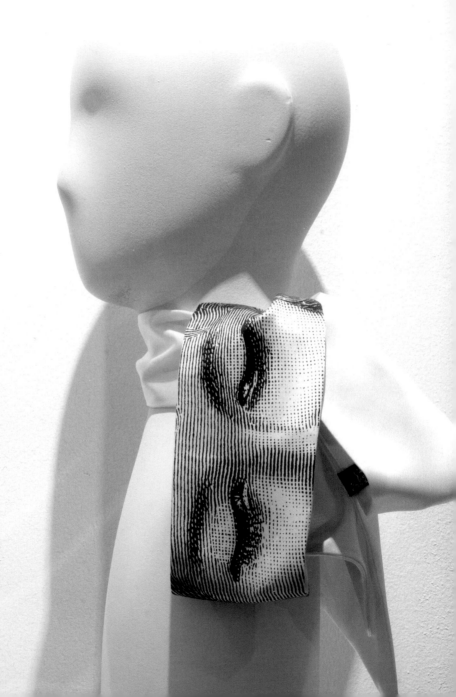

Introduction

London's industrial past has left a marked trace on the city; the urbanistic profile of this British capital has remained dotted with innumerable nineteenth-century edifices which, formerly destined for industrial activities, have undergone remodeling operations and been made over into houses or offices.

Following a period of strong industrial activity, the decade of the 1980s saw the city caught up in an important transformation that would lead it to plan an urbanistic refurbishment based on the recovery of unoccupied factory spaces. This revitalization process found its maximum apogee in the following ten-year period and culminated with the construction of the Tate Modern, a museum which has restored activity to this former power station and which in only a few years has come to hold an important place in the vanguard of international museums, together with the generation of young artists championed by gallery owner Charles Saatchi.

But it's really in the street where life pulsates with more intensity; new galleries, shops, restaurants and pubs convert the town into a public space that can be enjoyed at all hours. The new design locales as well as the more classical ones cover a spectrum as wide as the multi-culturalism of London itself and present an offer that covers the five continents and would be difficult to find in other cities. The degree of specialization of each establishment is very high and makes it possible to find anything from toys to exotic food products; however, what stands out most are the latest trends in the world of fashion and design. The town is intoxicated by the work of British designers of the stature of Vivienne Westwood, Paul Smith or Stella McCartney, whose presence is becoming increasingly consolidated on the international fashion runways. Milan and Paris are no longer the only fashion capitals; London is receptive to the changes in this dimension and absorbs the best of the large European cities and of its former colonies to create a new twenty-first century vanguard that pools their energies and maintains the unity of difference.

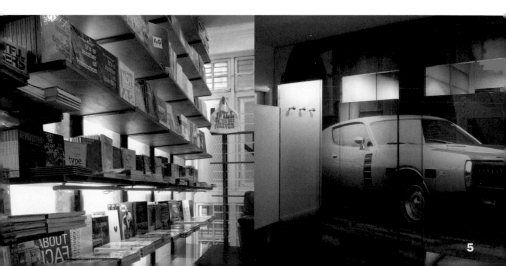

Einleitung

Die industrielle Vergangenheit Londons hat tiefe Spuren in der Stadt hinterlassen. Die britische Hauptstadt ist voller Gebäude aus dem 19. Jahrhundert, in denen sich einst Fabriken befanden und die heute als Wohnungen oder Büroräume genutzt werden.

Nach einer von intensiver industrieller Aktivität geprägten Epoche fand in den Achtzigerjahren des vergangenen Jahrhunderts eine große Umgestaltung der Stadt statt, während der die ehemaligen, leer stehenden Fabrikhallen für andere Zwecke umgebaut wurden. Dieser Wiederbelebungsprozess intensivierte sich im darauffolgenden Jahrzehnt noch und gipfelte in der Errichtung der Tate Modern, einem Museum, das diesem alten Kraftwerk wieder einen Sinn gab und wenige Jahre später bereits zur internationalen Avantgarde der Museen gehört. Gleichzeitig machte eine vom Galeristen Saatchi geförderte Generation junger Künstlern auf sich aufmerksam.

Aber nicht in den Museen, sondern auf der Straße pulsiert das Leben in seiner ganzen Intensität, und dort verwandeln neue Galerien, Shops, Restaurants und Pubs die Stadt in eine öffentliche Umgebung, die zu jeder Tages- und Nachtzeit etwas zu bieten hat. Lokale im neuen Design und klassischer gestaltete Räumlichkeiten sind so vielfältig wie es auch die multikulturellen Einwohner Londons sind. Dieses Angebot, das man nur schwer in einer anderen Stadt finden kann, umfasst alle fünf Kontinente. Die einzelnen Geschäfte haben sich sehr spezialisiert und bieten alles Mögliche wie z. B. exotische Spielzeuge und Lebensmittel. Der Schwerpunkt des Angebotes liegt jedoch auf den neusten Trends aus der Welt der Mode und des Designs. Die Stadt lässt sich von den Arbeiten so berühmter britischer Modeschöpfer wie Vivienne Westwood, Paul Smith und Stella McCartney berauschen, die auf den internationalen Laufstegen mittlerweile ein große Rolle spielen. Mailand und Paris sind nicht mehr die einzigen Hauptstädte der Mode. London ist sehr empfänglich für die Veränderungen in der Modewelt und nimmt das Beste aus den großen europäischen Hauptstädten und aus seinen ehemaligen Kolonien in sich auf, um die neue Avantgarde des 21. Jahrhunderts zu schaffen, die ihre Energien sammelt und die Einheit des Unterschieds bewahrt.

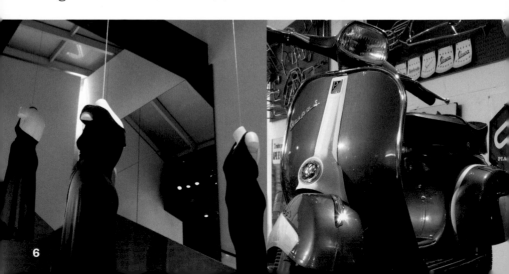

Introduction

Londres a été profondément marquée par son passé industriel. En effet, le péri-mètre urbain de la capitale britannique est ponctué d'innombrables édifices du XIXe siècle qui, jadis destinés à des activités manufacturières, ont été remode-lés et convertis en habitations ou bureaux.

Après la période d'intense activité industrielle la ville subit une transformation totale qui, aux années quatre-vingt, l'a poussée à remodeler les contours de son paysage urbain en récupérant les espaces industriels désaffectés. Au cours de la décennie suivante, ce processus de réhabilitation atteint son apogée dont la construction de la Tate Modern est l'apothéose. Ce musée qui a fait revivre cette ancienne centrale électrique n'a pas attendu de longues années pour se situer à l'avant-garde des musées internationales, se faisant l'écho de l'élan créateur de la génération de jeunes artistes propulsés par la galeriste Saatchi.

Mais c'est surtout dans la rue que la vie bat son plein : nouvelles galeries, bou-tiques, restaurants et pubs métamorphosent la ville en place publique disponi-ble à toute heure. L'éventail des établissements au design novateur ou clas-sique est vaste et diversifié à l'image même de la population londonienne. L'offre sans pareil, nulle part ailleurs, puise dans les cinq continents. Le taux de spécialisation de chaque établissement est très élevé et s'étend des jouets aux produits alimentaires exotiques. Toutefois, les dernières tendances du monde de la mode et du design tiennent le haut du pavé. La ville se grise des œuvres de designers britanniques de renom comme Vivienne Westwood, Paul Smith et Stella McCartney, que l'on voit de plus en plus sur les passerelles de la scène internationale. Milan et Paris ne sont plus les seules capitales de la mode. Londres est sensible aux changements du monde actuel et absorbe la quintessence des grandes villes européennes et de ses anciennes colonies pour créer une nouvelle avant-garde du XXIe siècle qui sait conjuguer les éner-gies et cultiver l'unicité de la différence.

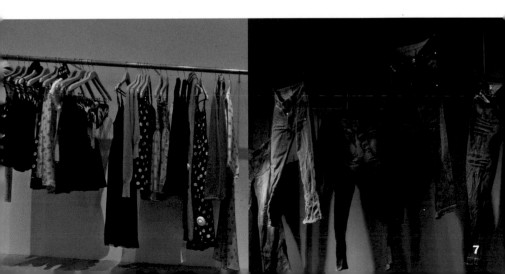

Introducción

El pasado industrial de Londres ha dejado una marcada huella en la ciudad; el trazado urbanístico de la capital británica ha quedado salpicado de innumerables edificios del siglo XIX que, otrora destinados a actividades fabriles, han sido remodelados y convertidos en viviendas u oficinas.

Tras una época de fuerte actividad industrial, en la década de los ochenta la ciudad experimentó una importante transformación que la llevó a plantear una remodelación urbanística basada en la recuperación de espacios fabriles desocupados. Este proceso de revitalización tuvo su máximo apogeo en el decenio siguiente y culminó con la construcción de la Tate Modern, un museo que ha devuelto la actividad a esta antigua central eléctrica y que en pocos años se ha situado en la vanguardia museística internacional, a la par de la generación de jóvenes artistas impulsada por el galerista Saatchi.

Pero es en la calle donde la vida palpita con más intensidad; nuevas galerías, tiendas, restaurantes y pubs convierten la ciudad en un espacio público que puede aprovecharse a todas horas. Los locales de nuevo diseño y los más clásicos cubren un espectro tan amplio como la multiculturalidad de la población londinense y presentan una oferta que abarca los cinco continentes y que difícilmente puede encontrarse en otras ciudades. El índice de especialización de cada establecimiento es muy elevado y se pueden encontrar desde juguetes hasta exóticos productos alimenticios; sin embargo, lo más destacado son las últimas tendencias del mundo de la moda y el diseño. La ciudad se embriaga con los trabajos de diseñadores británicos de la talla de Vivienne Westwood, Paul Smith o Stella McCartney, cuya presencia se consolida cada vez más en las pasarelas internacionales. Milán y París ya no son las únicas capitales de la moda; Londres se muestra receptiva a los cambios de ese mundo y absorbe lo mejor de las grandes ciudades europeas y de sus ex colonias para crear una nueva vanguardia del siglo XXI que suma energías y mantiene la unidad de la diferencia.

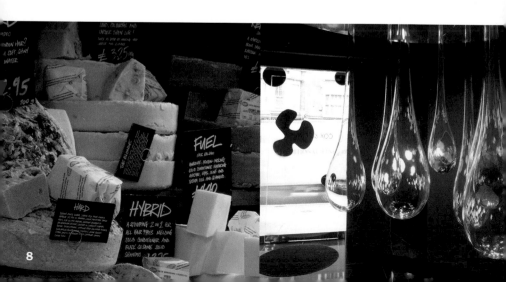

Introduzione

Il passato industriale di Londra ha lasciato un marchio importante nella città; il tracciato urbanistico della capitale britannica, infatti, è caratterizzato da numerosi edifici del XIX secolo destinati nel passato ad attività industriali che sono stati rimodellati e convertiti in abitazioni ed uffici.

Dopo un periodo di fervente attività industriale, negli anni ottanta la città ha vissuto un'importante trasformazione che ha portato alla pianificazione di un nuovo modello urbanistico basato sul recupero degli spazi industriali abbandonati. Questo processo di rivitalizzazione raggiunse il suo apogeo nel decennio successivo e culminò con la costruzione della Tate Modern, un museo che ha ridato vita a una vecchia centrale elettrica e che in pochi anni è entrato a far parte dell'avanguardia nel panorama museale internazionale, alla pari della generazione di giovani artisti lanciata dal gallerista Saatchi.

Le strade rappresentano il luogo dove la vita palpita con maggiore intensità; nuove gallerie, negozi, ristoranti e pub trasformano la città in uno spazio pubblico di cui approfittare a tutte le ore. I nuovi locali di design e quelli più classici coprono uno spettro tanto ampio quanto la multiculturalità della popolazione londinese e presentano un'offerta che include i cinque continenti e che difficilmente si incontra in altre città. Il livello di specializzazione di ogni attività commerciale è molto elevato e si possono trovare dai giochi ai prodotti alimentari esotici; senza dubbio, il livello d'eccellenza è raggiunto con le ultime tendenze nel mondo della moda e del design. La città inebria con i lavori di stilisti britannici del calibro di Vivienne Westwood, Paul Smith e Stella McCartney, il cui valore trova puntualmente conferma sulle passerelle internazionali. Milano e Parigi non sono più le uniche capitali della moda; Londra si mostra ricettiva ai cambiamenti della modernità e assorbe il meglio delle grandi città europee e delle sue ex-colonie per creare una nuova avanguardia del XXI secolo che unisce energie diverse e mantiene unità nella differenza.

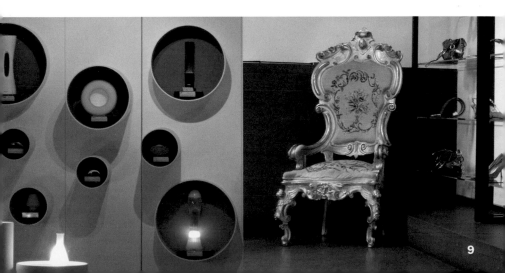

10500 Hairdressers

Design: Andy Martins Associates

284 Westbourne Park Road | Notting Hill, W11 1EH
Phone: +44 20 7229 3777
www.10500hair.com
Subway: Ladbroke Grove
Opening hours: Tue–Sat 10 am to 7 pm, Thu 10 am to 9 pm
Products: KMS Stockist
Special features: Internet connection freely available to customers, zen washing area and Chinese garden, smoking area

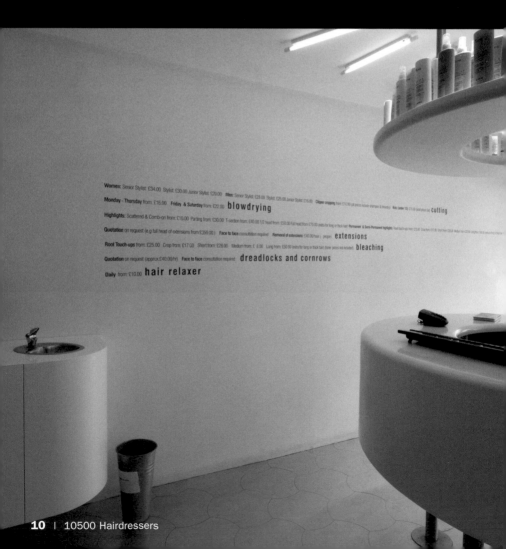

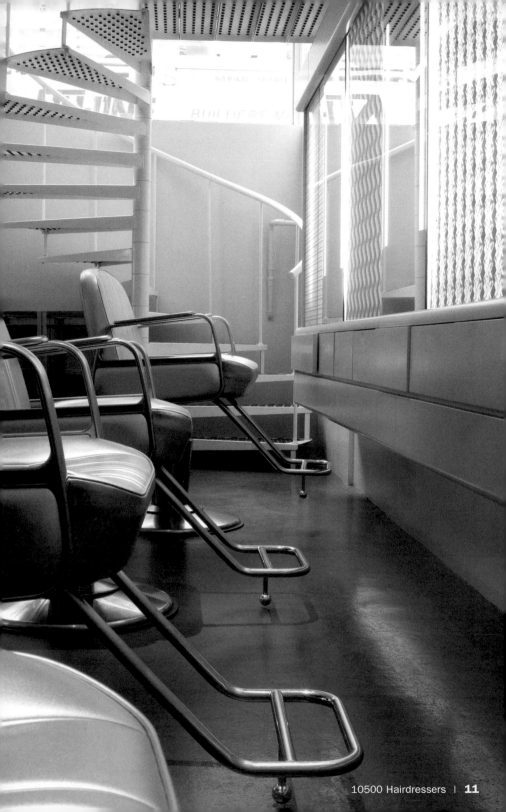

Alberta Ferretti

Design: David Ling

205–206 Sloane Street | Belgravia, SW1X 9QX
Phone: +44 20 7235 2349
www.albertaferretti.it
Subway: Knightsbridge
Opening hours: Mon–Sun 10 am to 6 pm
Products: Exquisite and feminine ladies designer wear
Special features: Light modern open space with sweeping staircase leading to the
first floor, "philosophy" diffusion line

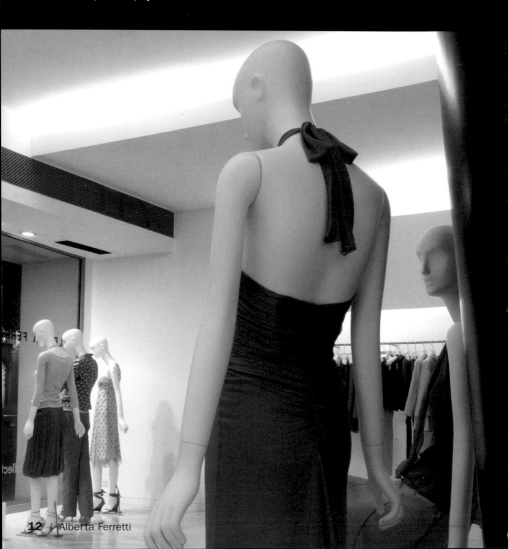

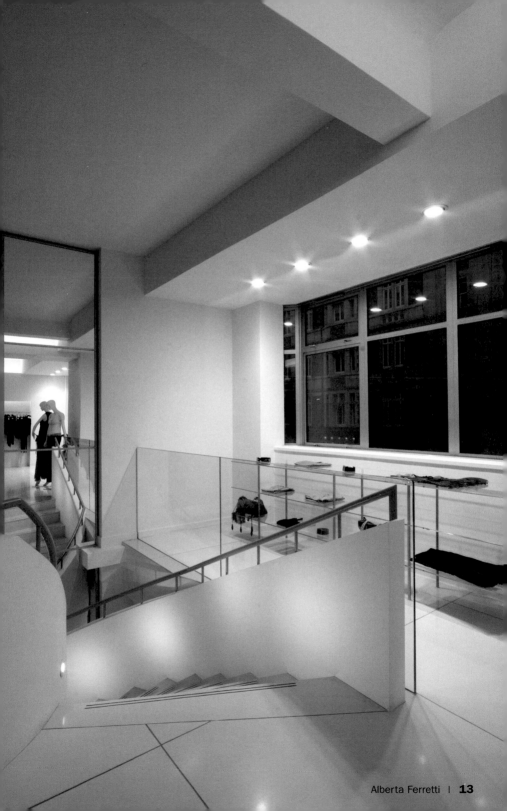

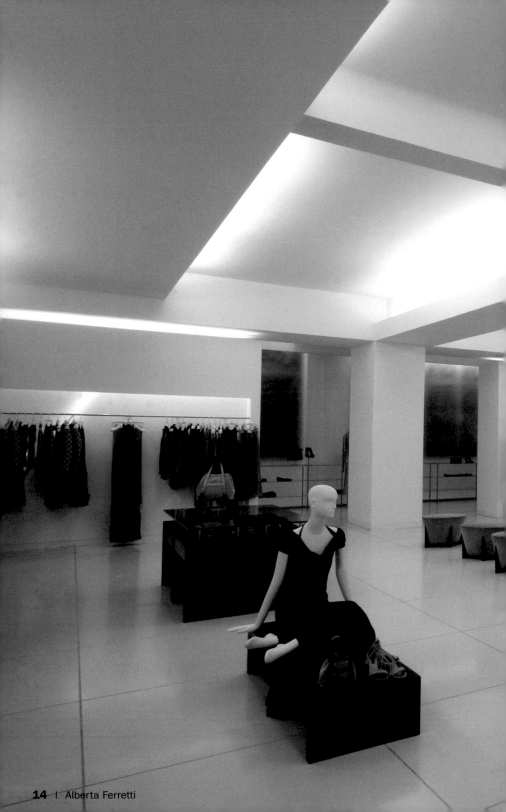

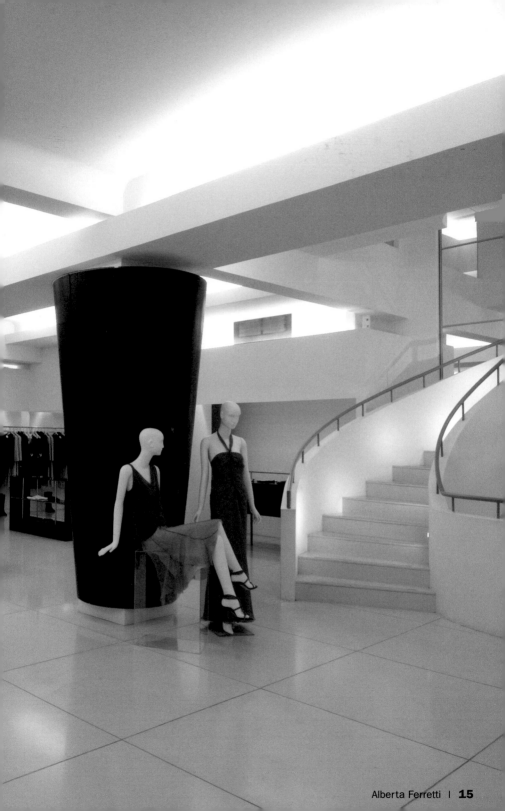

Allegra Hicks

Design: Ashley Hicks

28 Cadogan Place (entrance on Pont Street) I Belgravia, SW1X 9RX
Phone: +44 20 7235 8989
www.allegrahicks.com
Subway: Sloane Square, Knightsbridge
Opening hours: Mon–Sat 10 am to 6 pm
Products: Women's ready-to-wear, kaftans, accessories, home furnishings, table ware, bed and bath linen
Special features: Complete luxury lifestyle shop decorated like a home, style is very boho-chic

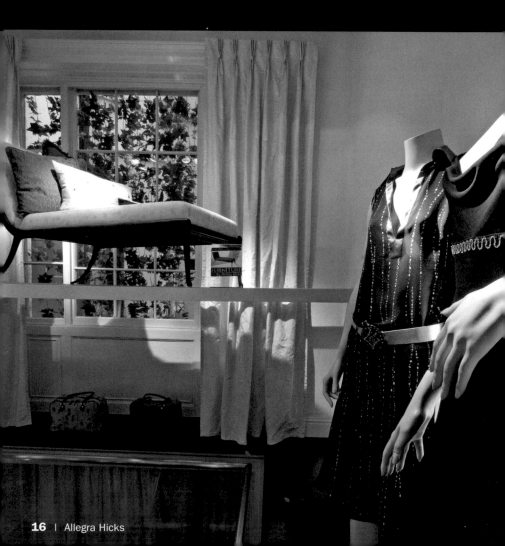

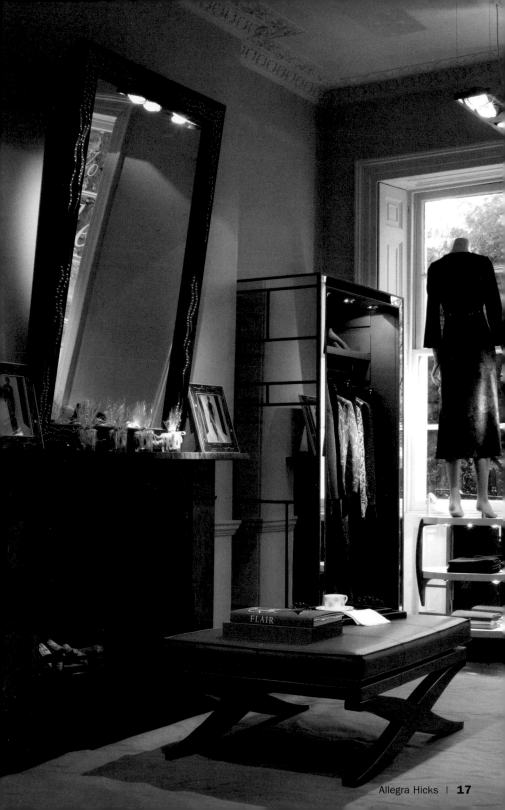

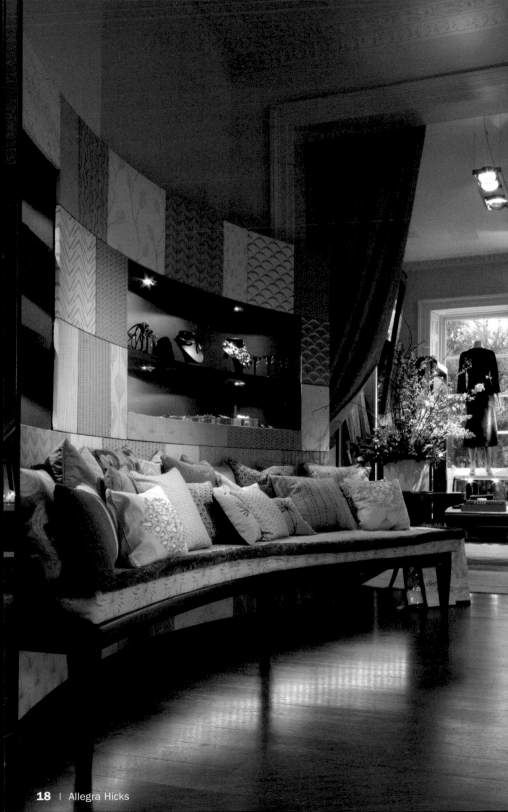

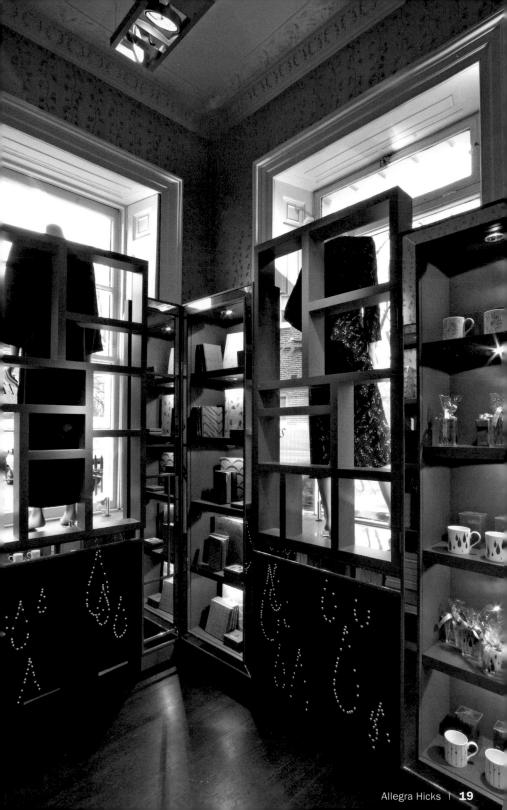

Comfort Station

Design: Amy Anderson

22 Cheshire Street | Shoreditch, E2 6EH
Phone: +44 20 7033 9099
www.comfortstation.co.uk
Subway: Shoreditch, Aldgate East, Liverpool Street
Opening hours: Fri–Sun 11 am to 6 pm, Mon–Thu by appointment
Products: Bags, accessories, small clothing selection

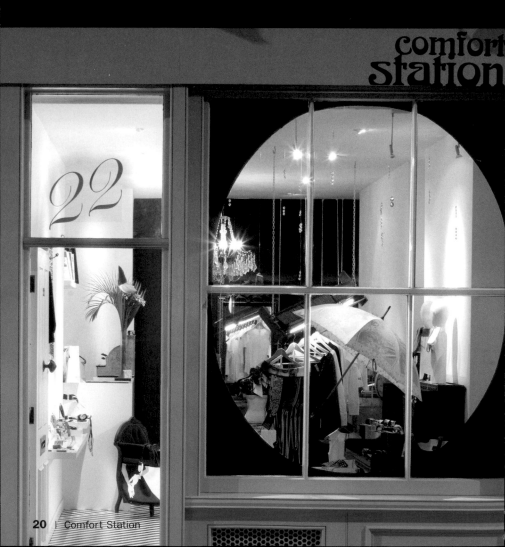

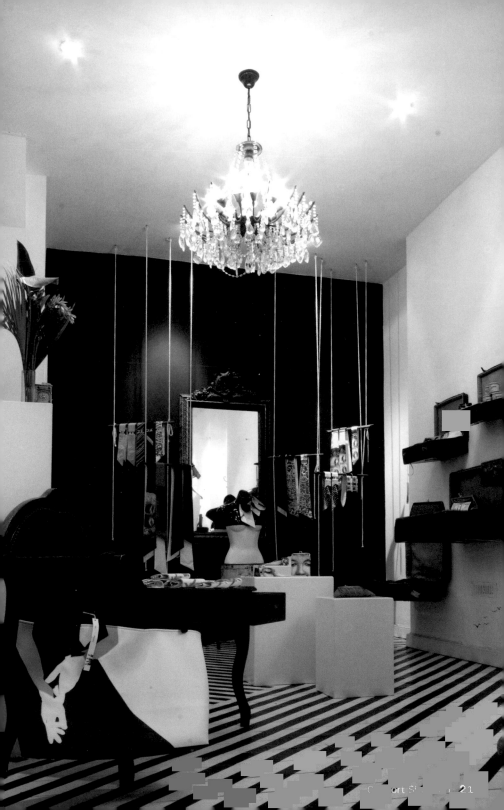

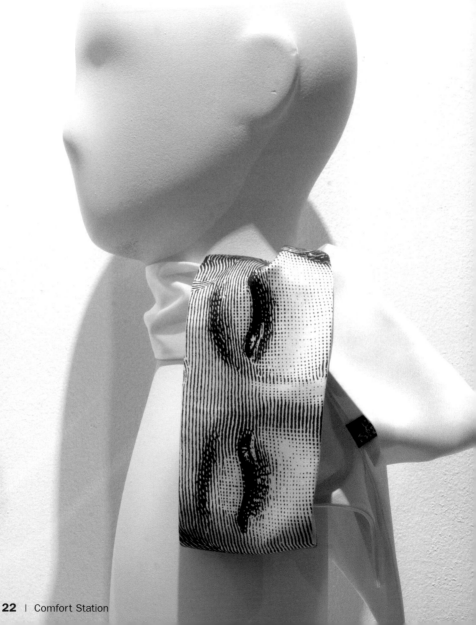

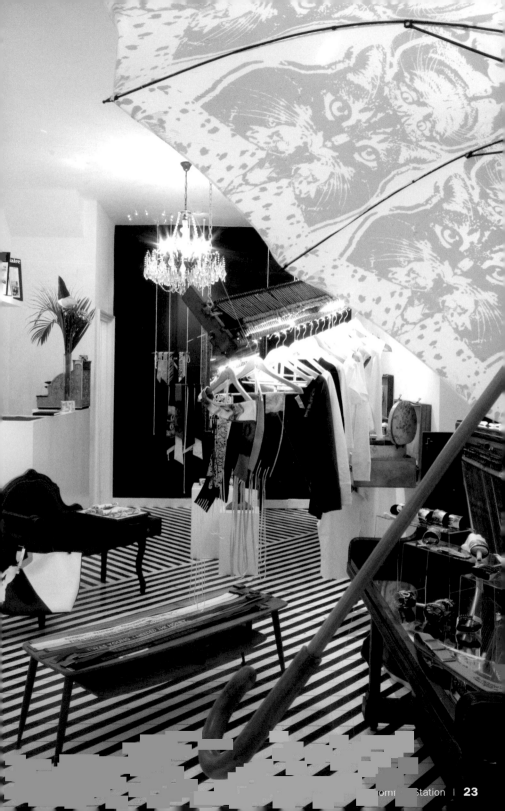

Cox & Power

Design: Sybarite

35c Marylebone High Street | Marylebone, W1U 4QA
Phone: +44 20 7935 3530
www.coxandpower.com
Subway: Bond Street, Baker Street
Opening hours: Mon–Sat 10 am to 6 pm, Thu 10 am to 7 pm
Products: Contemporary precious jewelry
Special features: Extravagant hand blown glass droplets suspended over mirror form
the centerpiece of the shop

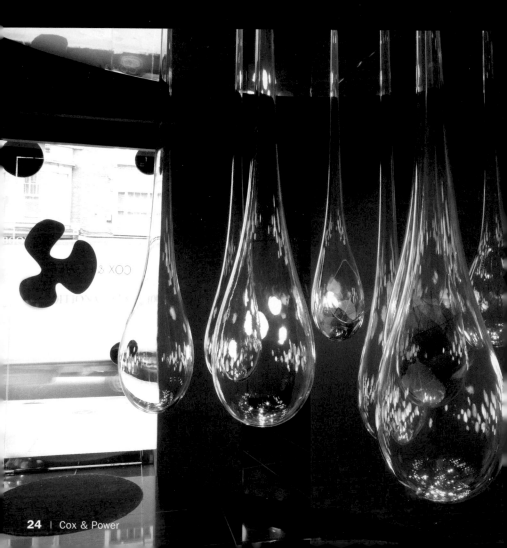

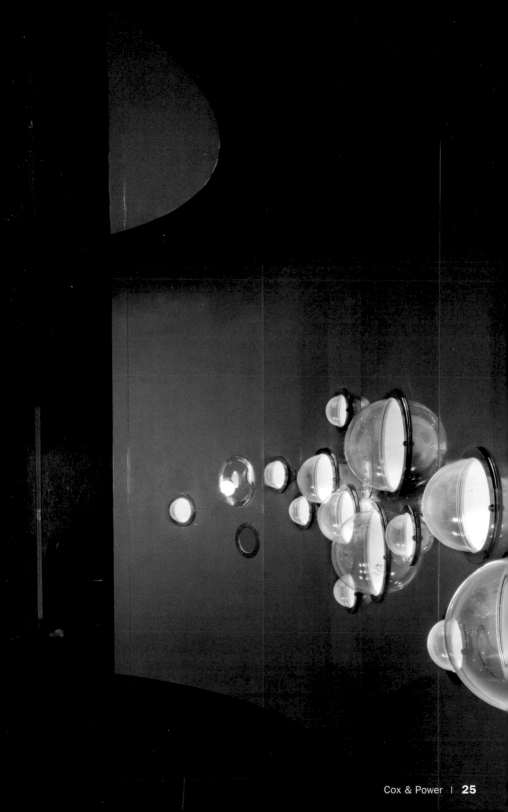

Diesel

Design: Diesel Creative Team

72 King's Road, Chelsea I Chelsea SW1
Phone: +44 20 7225 3225
www.diesel.com
Subway: Sloane Square
Opening hours: Mon–Sat 10 am to 7 pm, Wed 10 am to 8 pm, Sun 12 am to 6 pm
Products: All Diesel collections including male, female, denim, footwear, underwear, spare parts and luggage
Special Features: Honouring the architecture of this former Gentlemen's Club, the interior is a mixture of vintage elements and modern classics

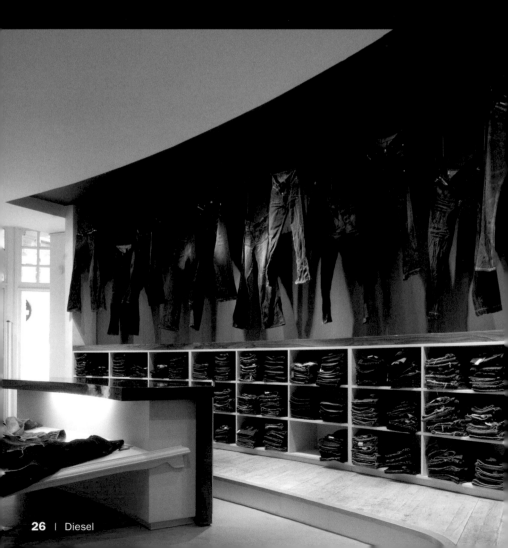

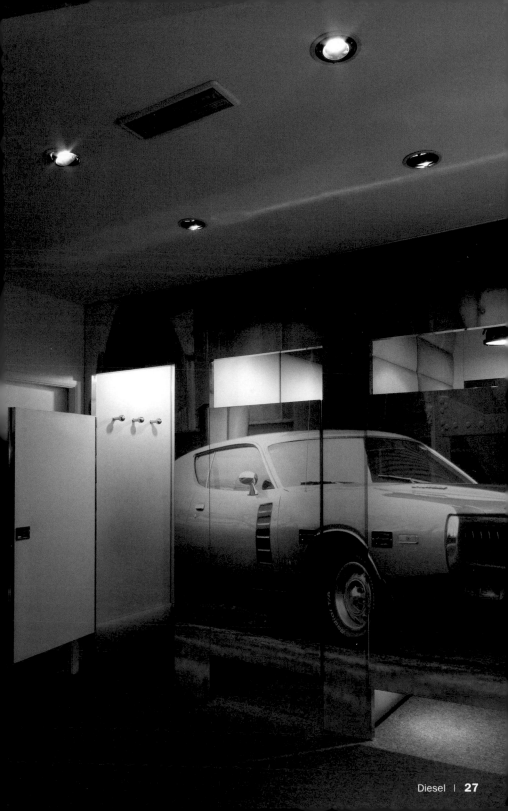

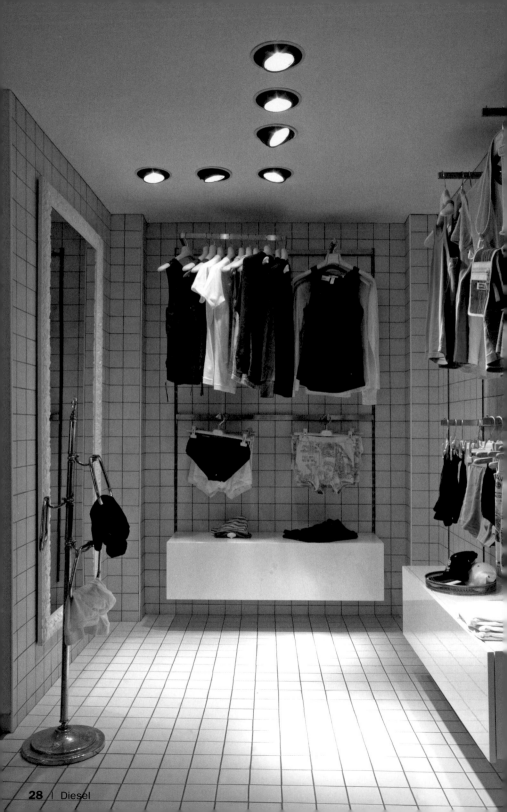

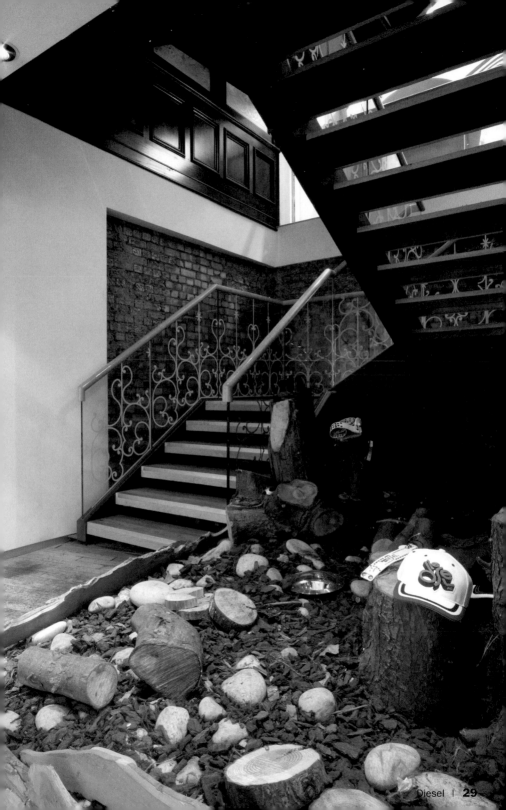

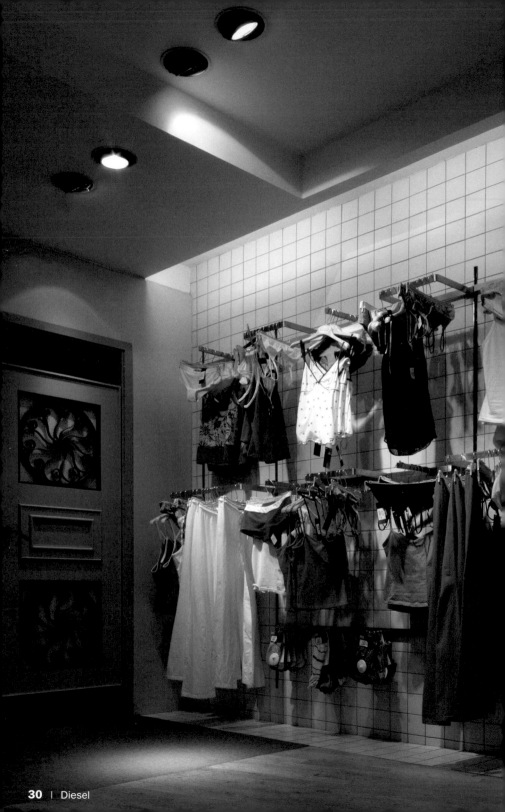

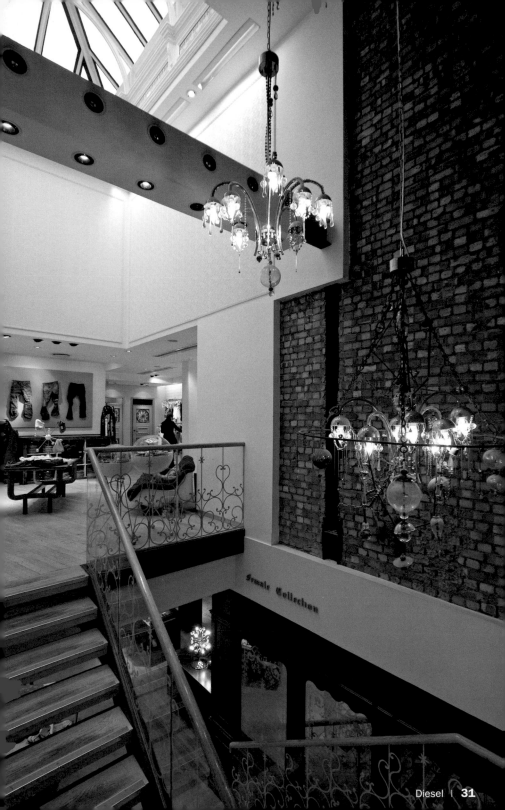

Female Collection

Dolce & Gabbana

Design: Domenico Dolce, Stefano Gabbana, David Chipperfield (architecture features), Ferruccio Laviani (interior)

Address: 175 Sloane Street | Belgravia, SW1X 9QG
Phone: +44 20 7201 0980
www.dolcegabbana.it
Subway: Knightsbridge
Opening hours: Mon–Sat 10 am to 6 pm, Wed 10 am to 7 pm
Products: Men's and women's ready-to-wear, accessories, sunglasses, books
Special features: A combination of Mediterranean elements like grey basalt stone and baroque features to create an eclectic and unique environment

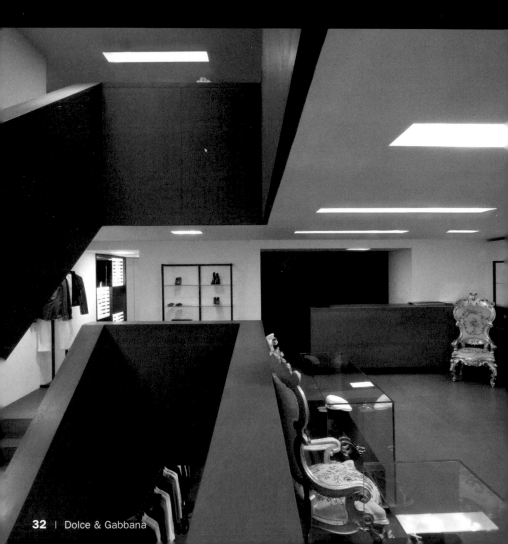

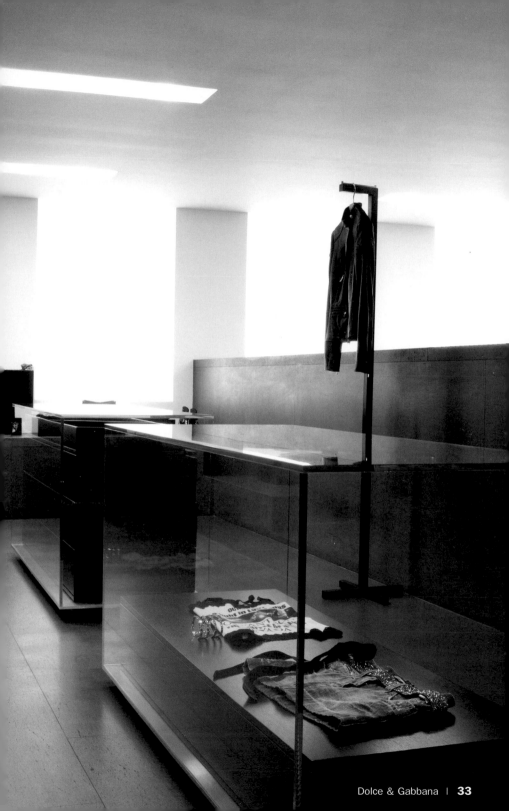

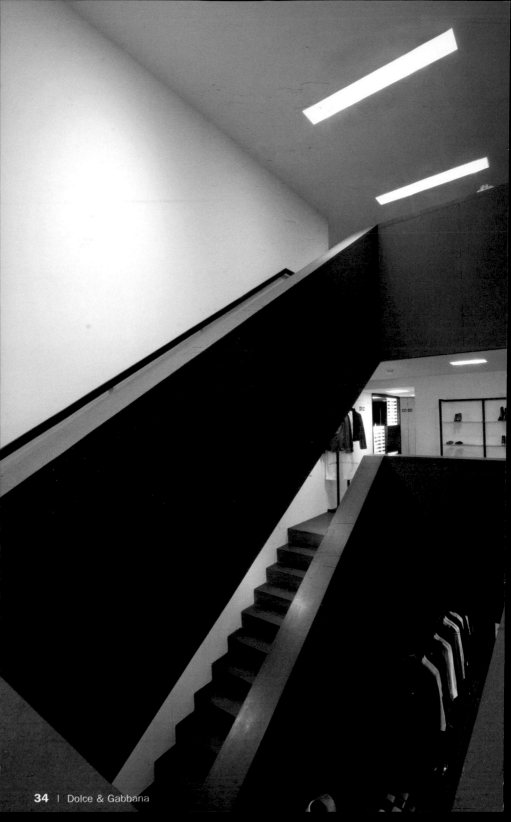

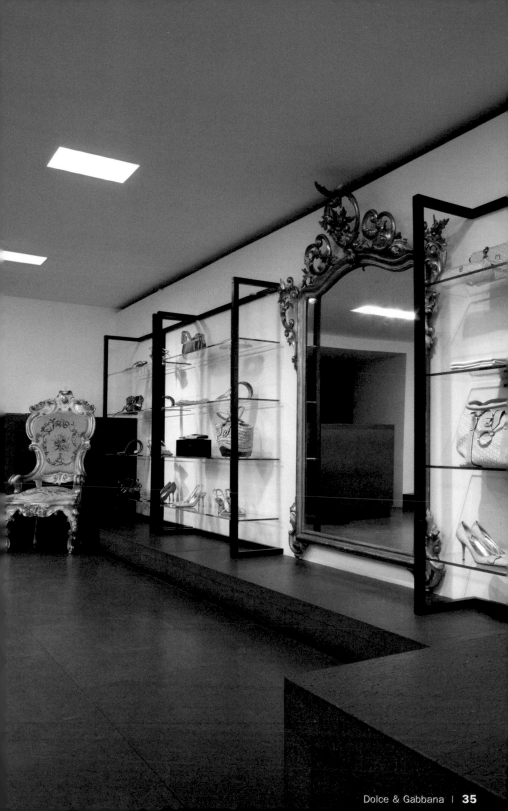

Donna Karan

Design: Donna Karan

19 New Bond Street I Mayfair, W1A 2RD
Phone: +44 20 7495 3100
www.donnakaran.com
Subway: Green Park, Bond Street
Opening hours: Mon–Wed and Fri–Sat 10 am to 6 pm, Thu 10 am to 7 pm
Products: Fashion
Special features: Homewear collection (only in New York and London), unique ceramics pieces

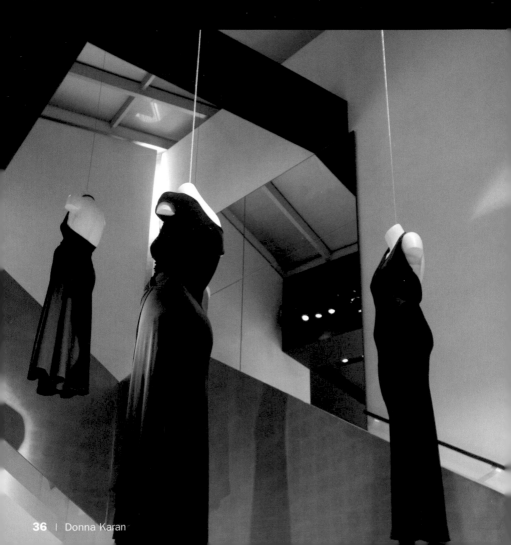

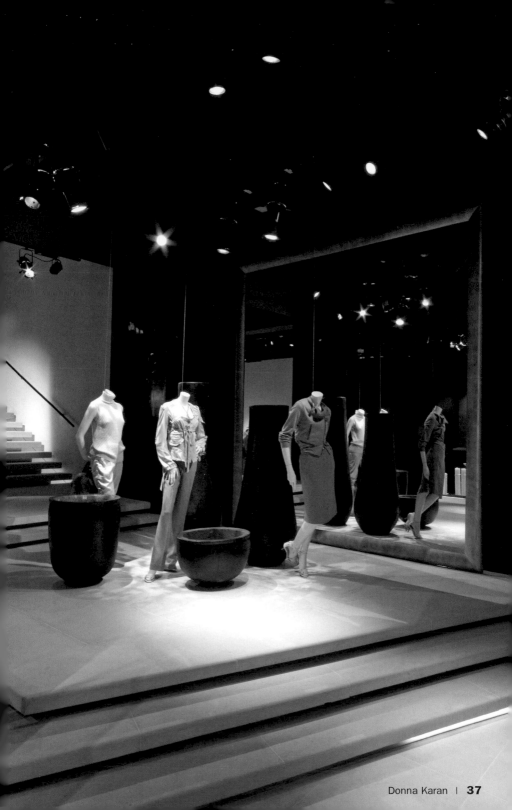

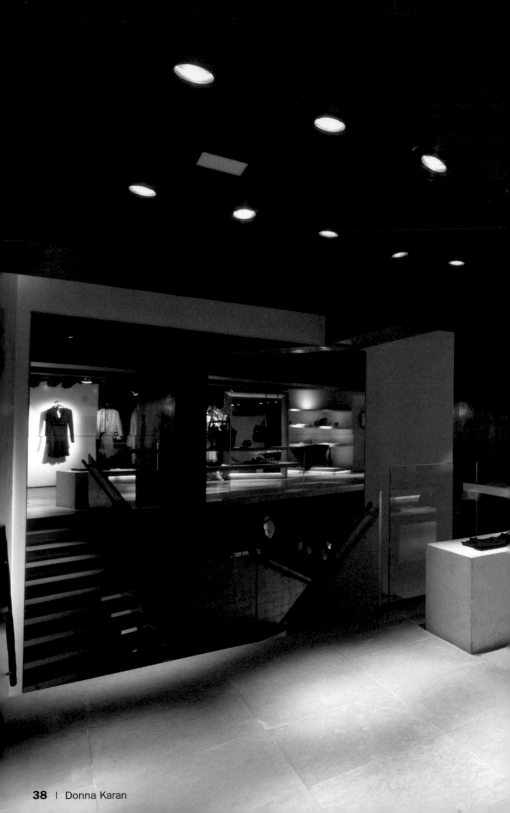

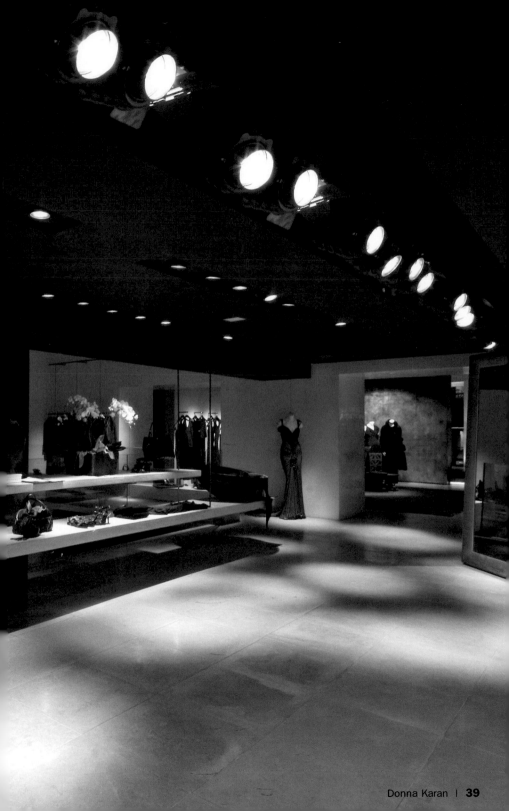

Dover Street Market

Design: Rei Kawakubo

17–18 Dover Street | Mayfair, W1S 4NL
Phone: +44 20 7518 0680
Subway: Green Park
Opening hours: Mon–Sat 11 am to 6 pm, Thu 11 am to 7 pm
Products: Fashion, furniture, objects, accessories
Special features: A market building in central London

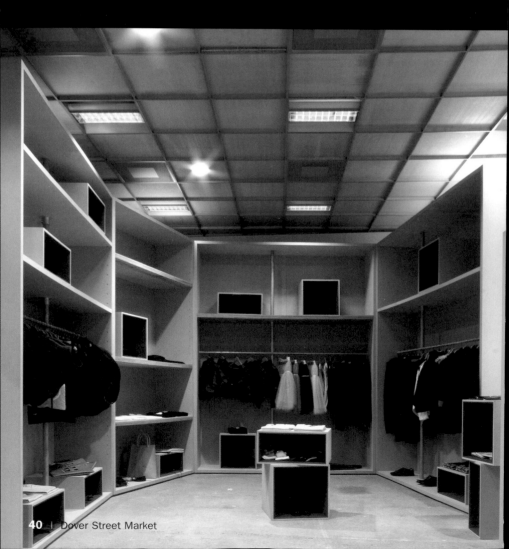

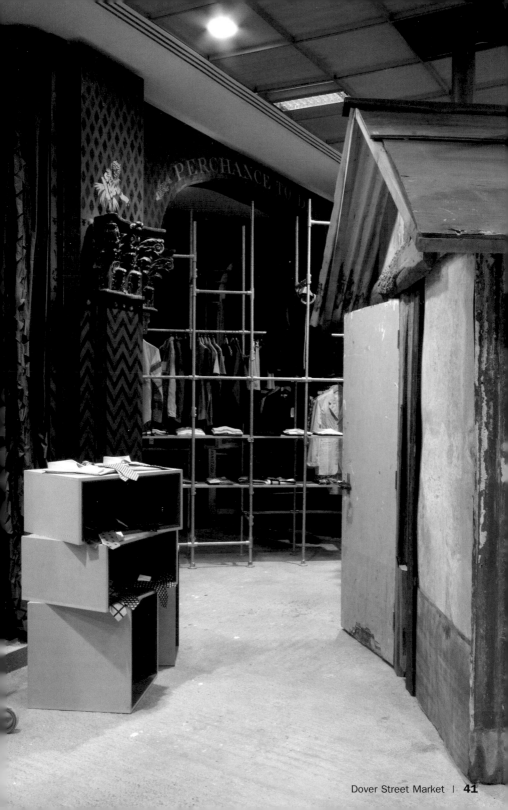

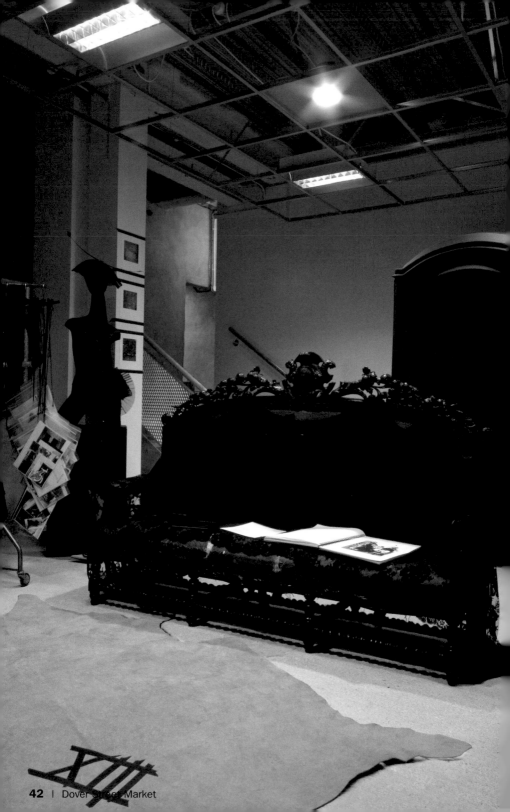

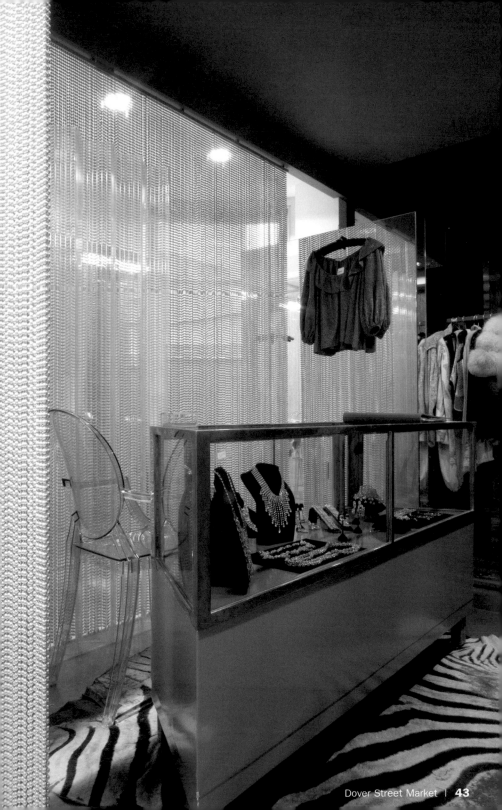

Emanuel Ungaro

Design: Antonio Citterio

150 New Bond Street | Mayfair, W1S 2TT
Phone: +44 20 7629 0550
www.emanuelungaro.com
Subway: Green Park, Bond Street
Opening hours: Mon–Sat 10 am to 6 pm
Products: Women's luxury fashion
Special features: Constant playing fashion show, pink glass staircase, window space
with views on iconic luxury shopping street

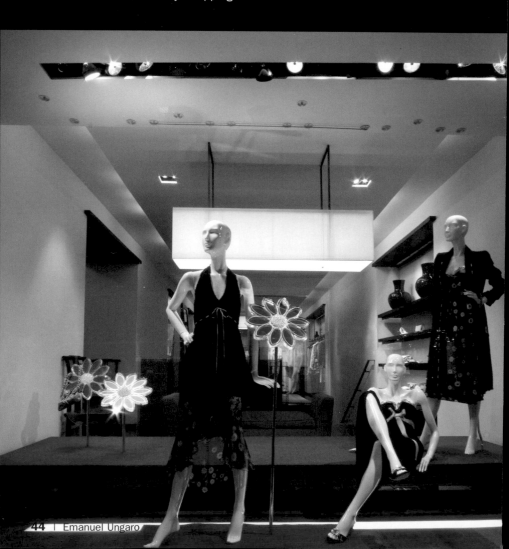

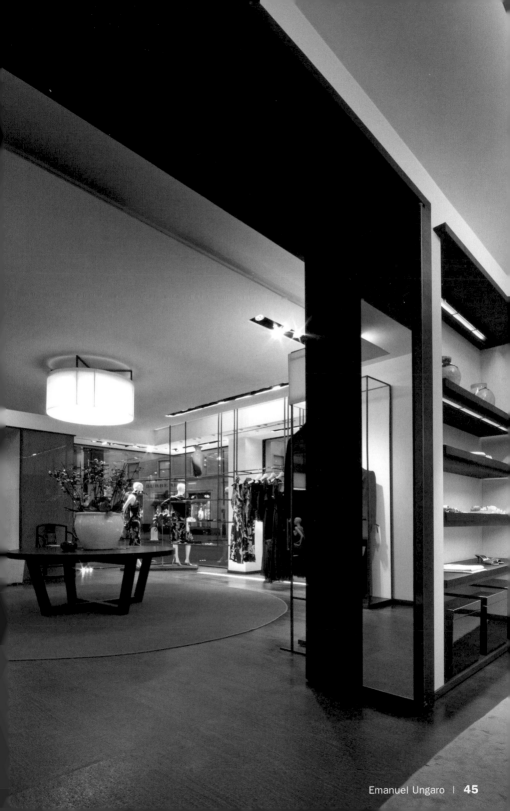

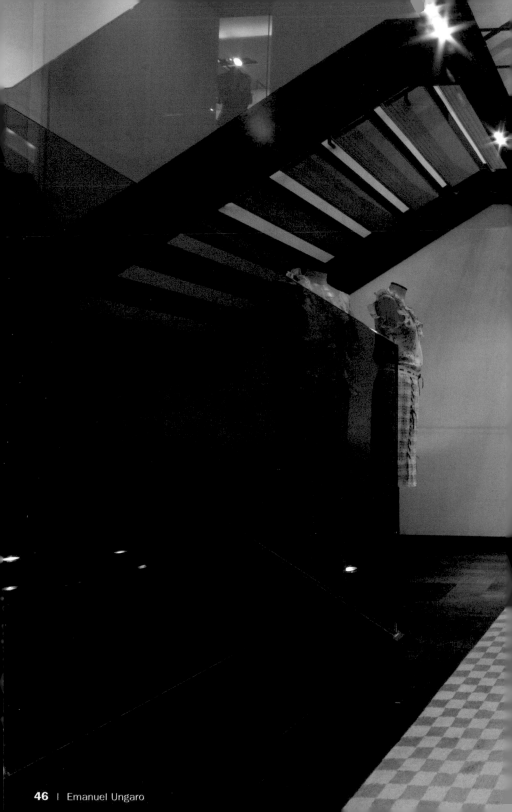

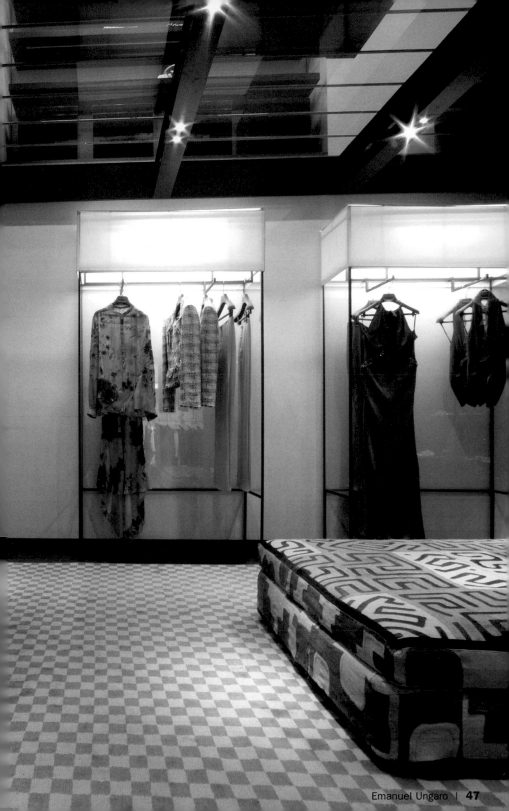

Erco

Design: Ken Shuttleworth / MAKE

38 Dover Street I Mayfair, W1S 4NL
Phone: +44 20 7408 0320
www.erco.com
Subway: Green Park
Opening hours: Mon–Fri 9 am to 5:30 pm
Products: Architectural light fittings
Special features: Interior spaces created only by light

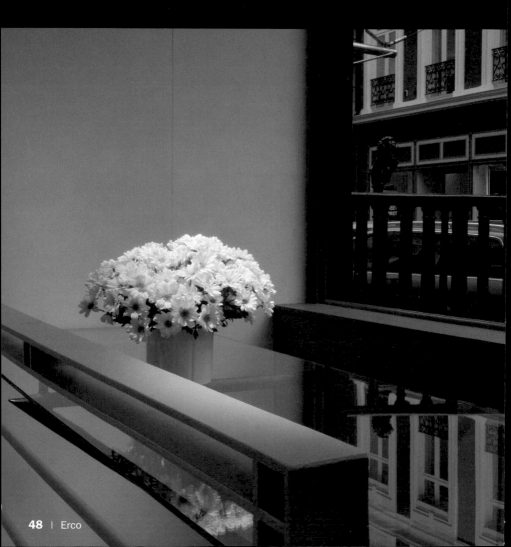

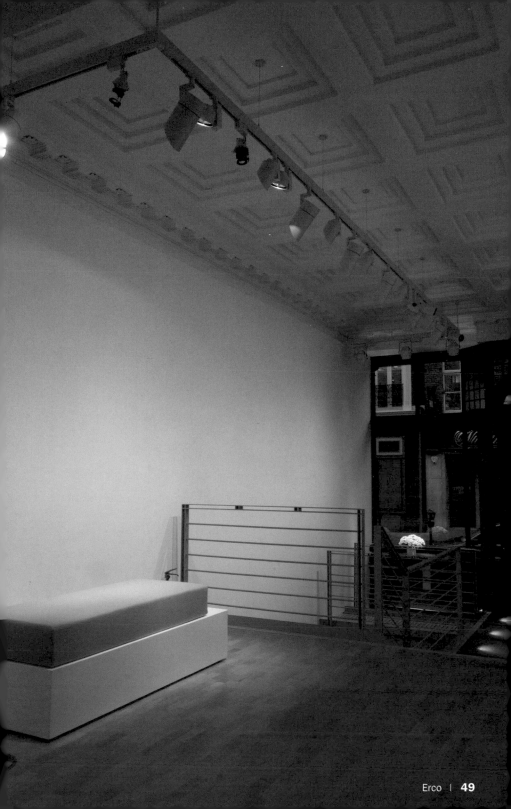

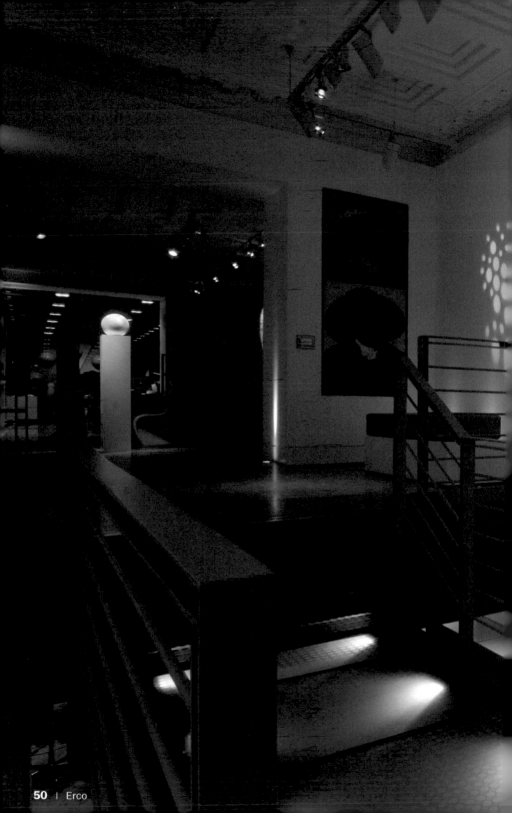

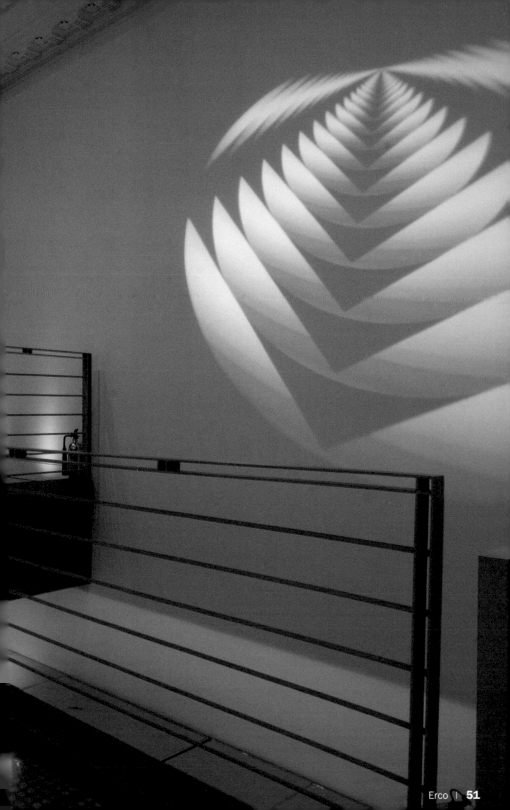

Espacio

Design: Raj Wilkinson

276 King's Road I Chelsea, SW3 5AW
Phone: +44 20 7376 5088
www.espacio.co.uk
Subway: Sloane Square
Opening hours: Mon–Sat 10 am to 6:30 pm, Sun 12 am to 5 pm
Products: Contemporary furniture
Special features: Furniture and lighting from the best Italian brands, exclusive range
of Espacio upholstery

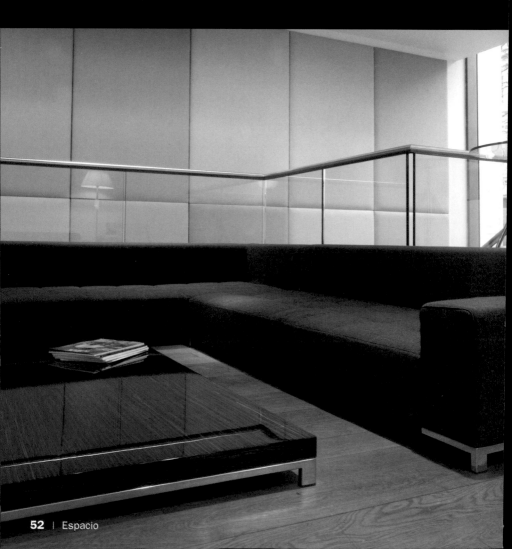

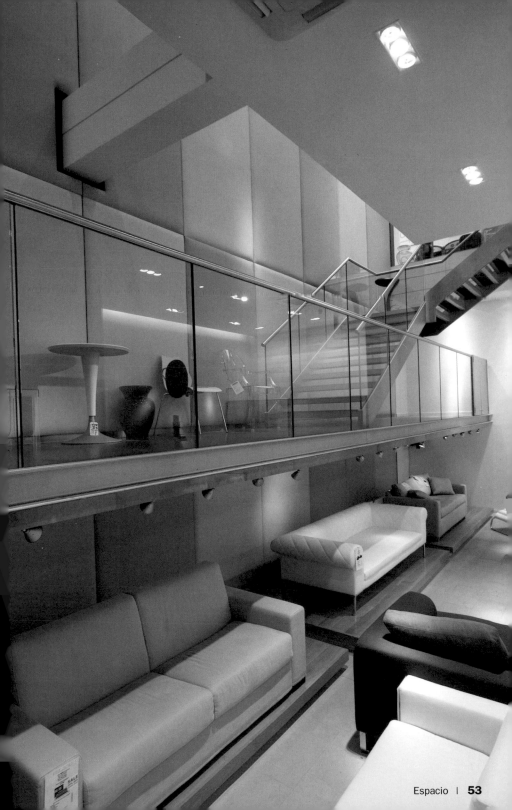

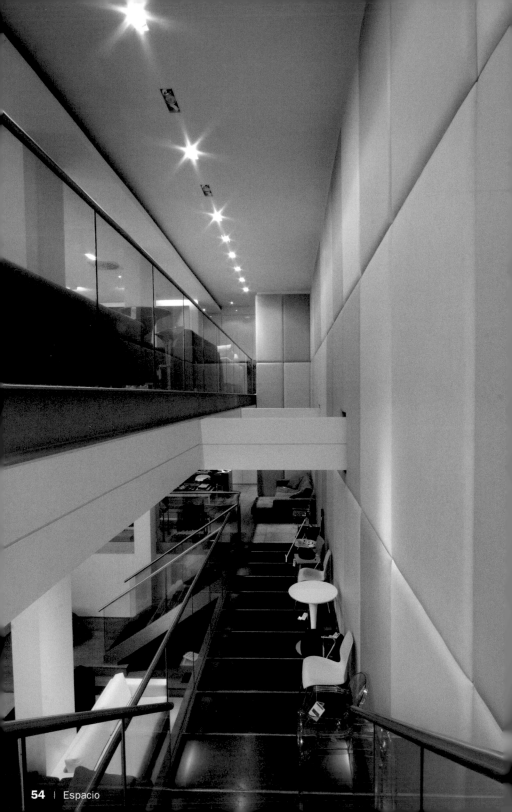

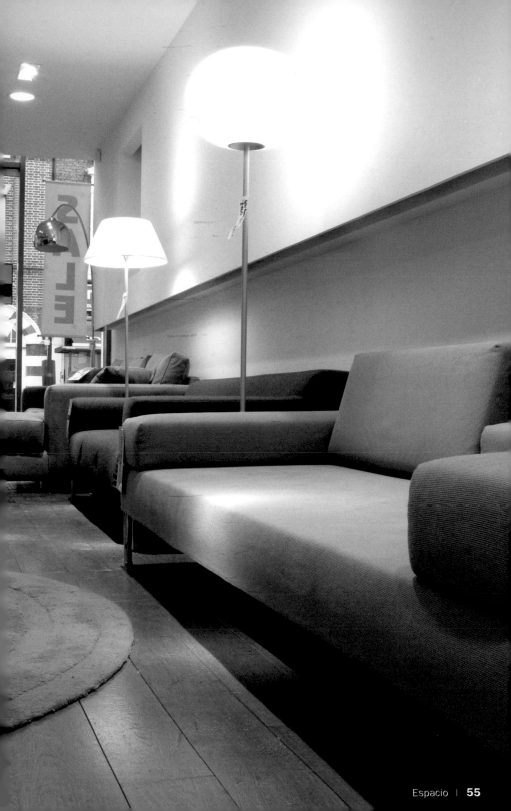

Junky Styling

Design: Annika Sanders, Kerry Seager

12 Dray Walk, The Old Truman Brewery, 91 Brick Lane I Shoreditch, E2 6RF
Phone: +44 20 7247 1883
www.junkystyling.co.uk
Subway: Liverpool Street, Aldgate East, Shoreditch
Opening hours: Mon–Fri 10:30 am to 6:30 pm, Sat–Sun 10:30 am to 5:30 pm
Products: Unique recycled clothing for men and women, accessories, jewelry
Special features: Original brickwork, natural wood, wardrobes and chandeliers create
an air of boudoir chic

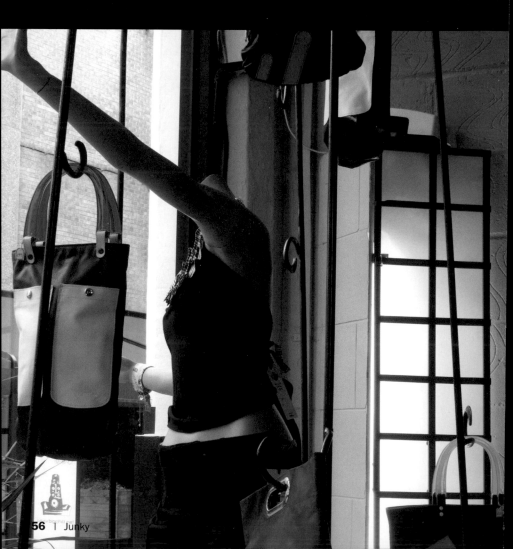

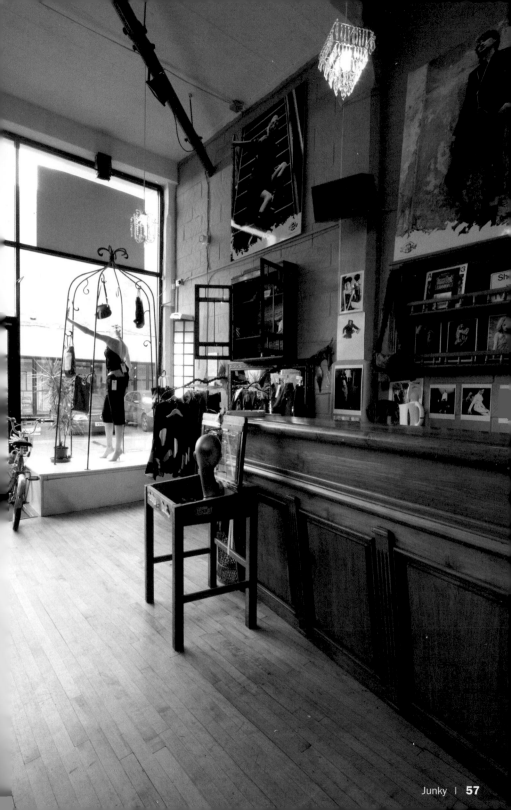

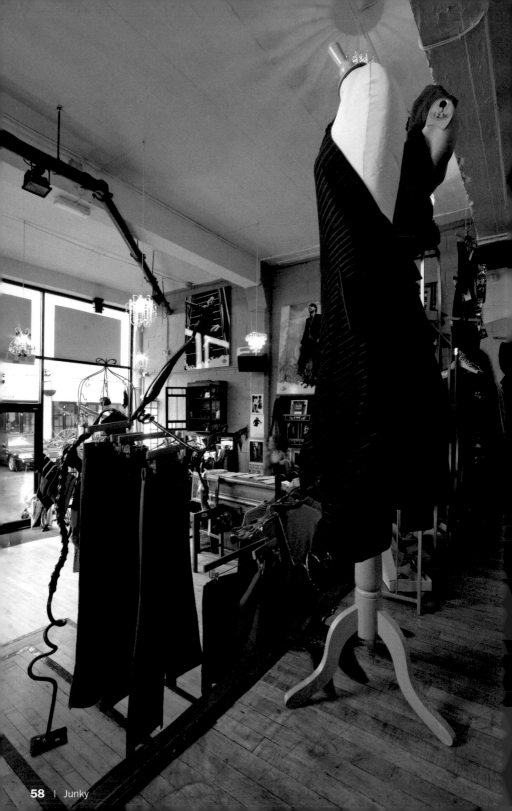

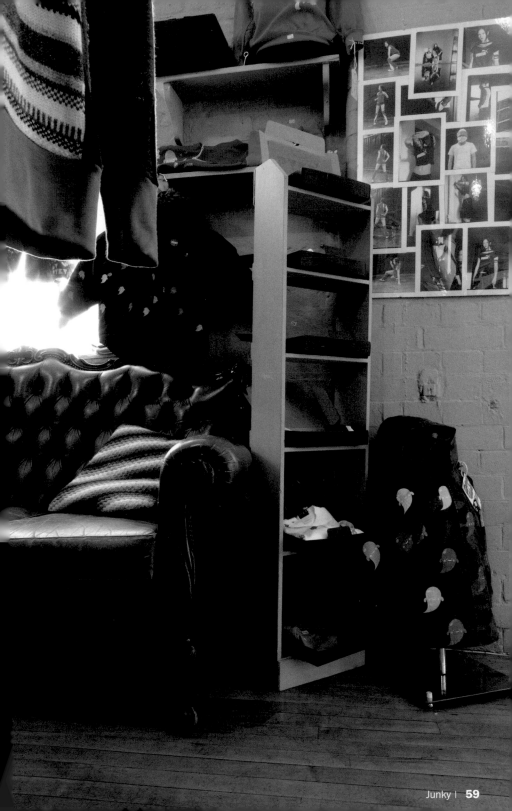

Laundry Industry

Design: Laundry Industry

186 Westbourne Grove | Notting Hill W11 2RH
Phone: +44 20 7792 7967
www.laundryindustry.com
Subway: Notting Hill Gate
Opening hours: Mon–Sat 10 am to 6 pm, Sun 1 pm to 6 pm
Products: Women's and men's contemporary fashion
Special features: Garage effect through a ramp with a 4% angle

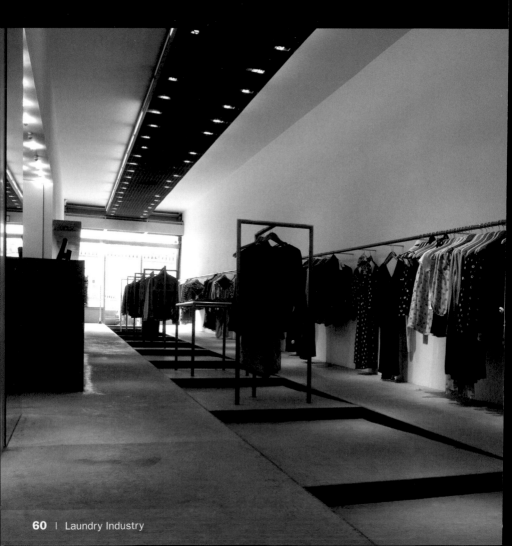

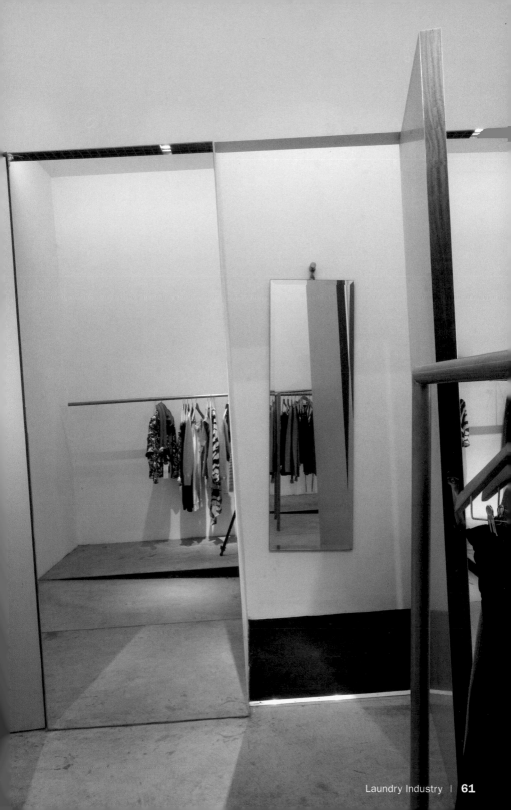

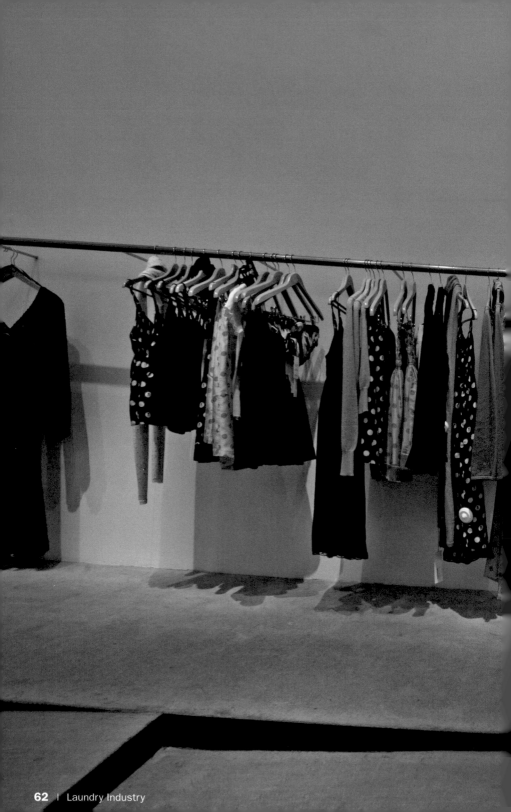

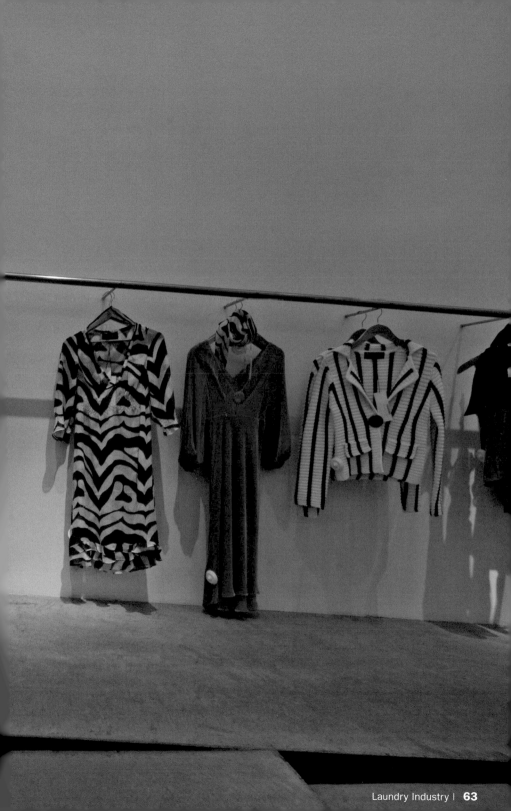

Lush

Design: Lush

40 Carnaby Street | Soho, W1V 1PD
Phone: +44 20 7287 5874
www.lush.com
Subway: Oxford Circus
Opening hours: Mon–Sat 10 am to 7 pm, Sun 12 am to 6 pm
Products: Cosmetics, perfumes, beauty products, gifts
Special features: Handmade fresh products

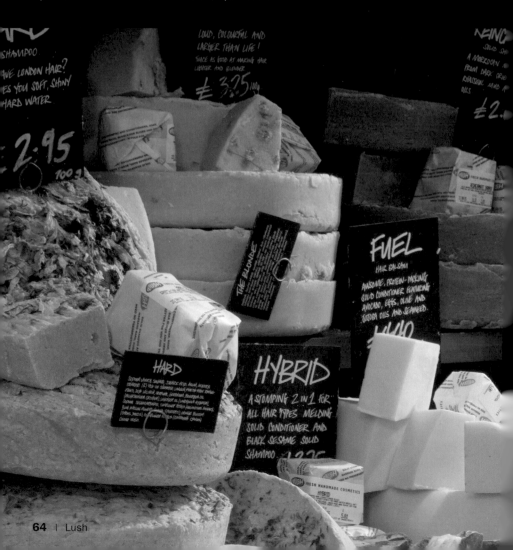

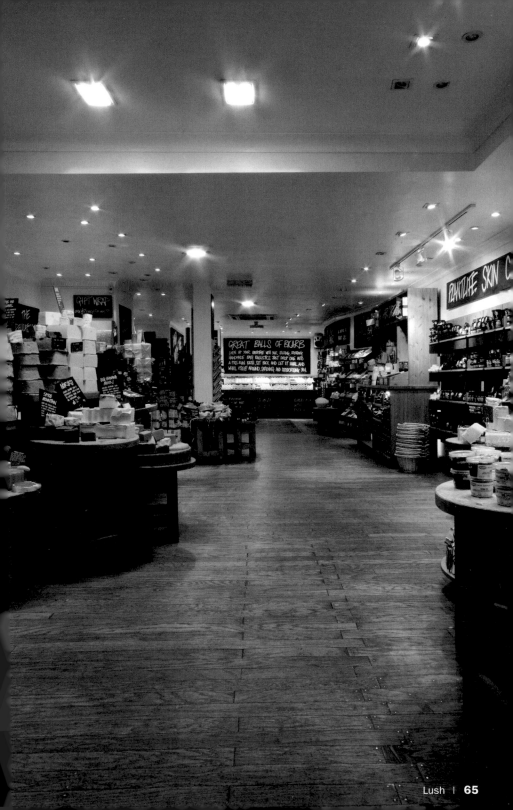

CUPCAKE

DEEP - CLEANSE WITH
OUR RICH CHOCOLATE
MASK WHICH
EVER SO
XCES

URSE
CARE

FOR ALL
TYPES.

S FRESH
KITCHEN
ULD APPROVE)

50

COSMETIC
WARRIOR

POWERFUL BUT GENTLE,
OUR GARLIC AND

WOW WOW

FEELING ANCIENT? PERK
UP YOUR SAD, DRY OLD
SKIN WITH OUR NATURALLY
REJUVENATING FRESH
FACE MASK - WOW!

£4.30 100g

CATASTROPHE
COSMETIC

BB SEAWEED

COOLING, CLEANSING
AND SOFTENING MADE
WITH SEAWEED AND
OLIVE OIL TO SOFTEN
AND TONE FOR
NORMAL SKIN.

£5.

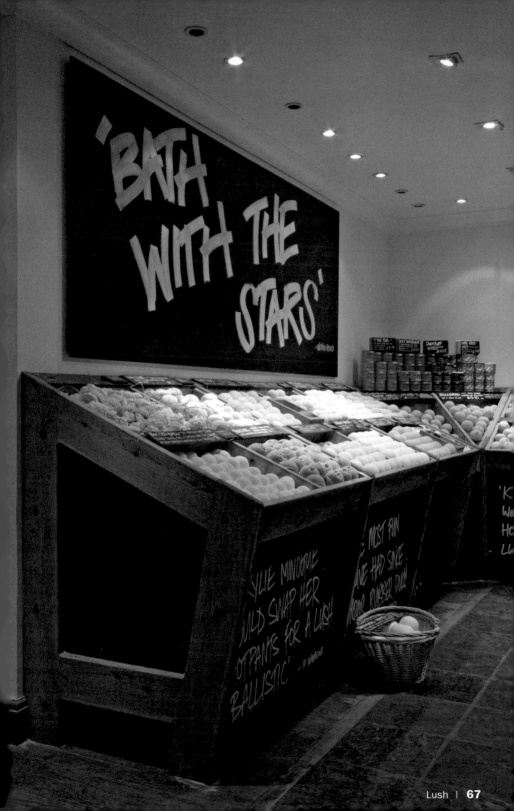

Magma

Design: Julie Blum InsideOut Systems

117–119 Clerkenwell Road | Clerkenwell, EC1R 5BY
Phone: +44 20 7242 9503
www.magmabooks.com
Subway: Chancery Lane, Farringdon
Opening hours: Mon–Sat 10 am to 7 pm
Products: Design and visual arts books, magazines, DVDs, toys, T-shirts, stationery and many other unusual and exciting products
Special features: Bespoke designed shelving system combined with feature lighting details to provide a space for inspiration

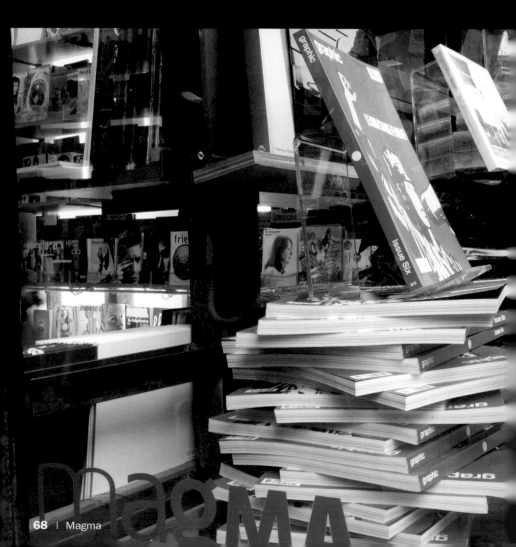

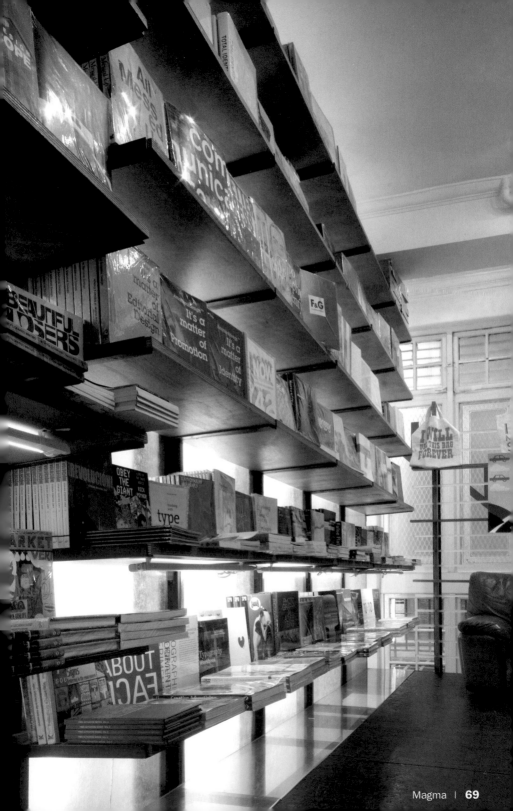

Mathmos

Design: Sam Hecht and Kim Collin / Industrial Facility

22–24 Old Street I St. Luke's, EC1V 9AP
Phone: +44 20 7549 2700
www.mathmos.com
Subway: Barbican, Old Street
Opening hours: Mon–Sat 9:30 am to 5:30 pm
Products: Innovative lighting designs
Special Features: High commended futuristic and playful flagship showroom that
encourages the viewer to look and interact with the designs

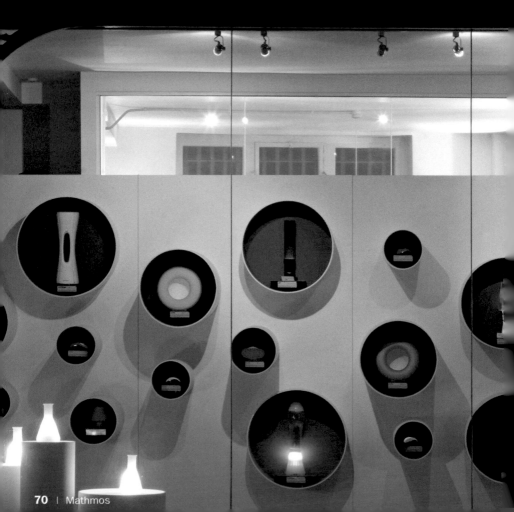

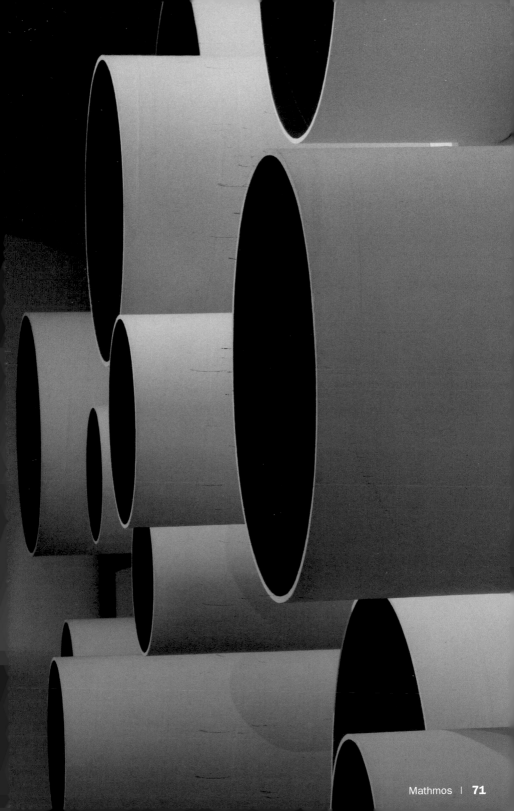

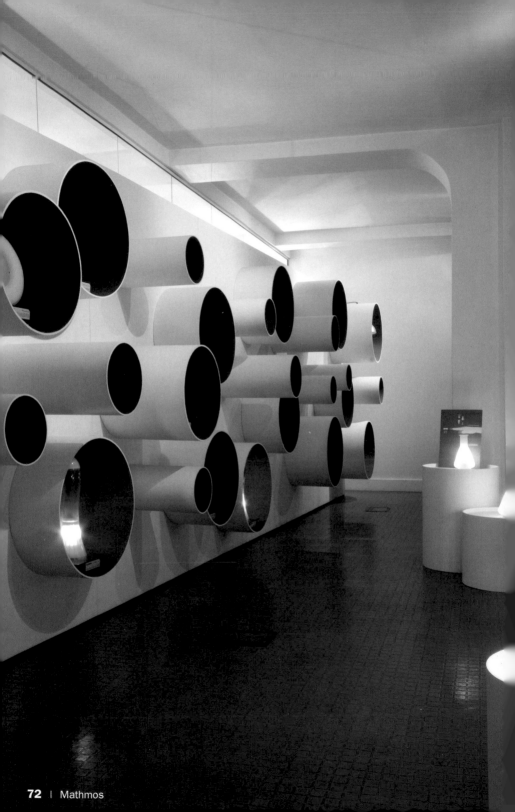

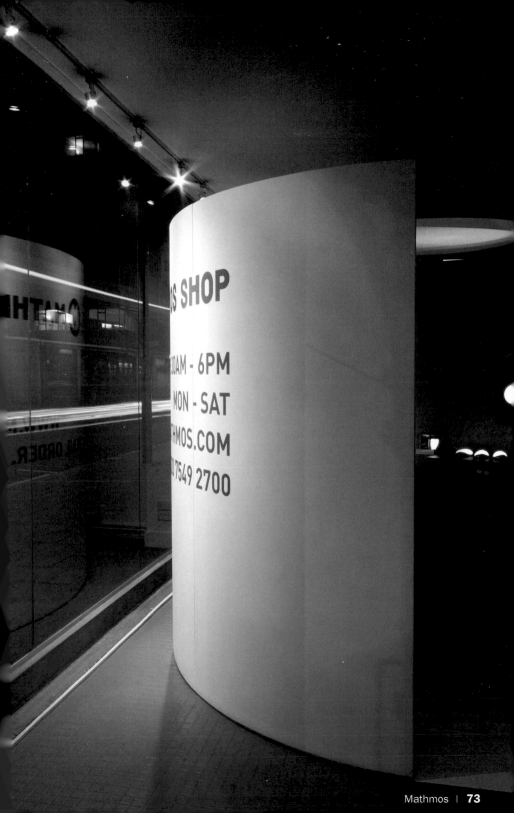

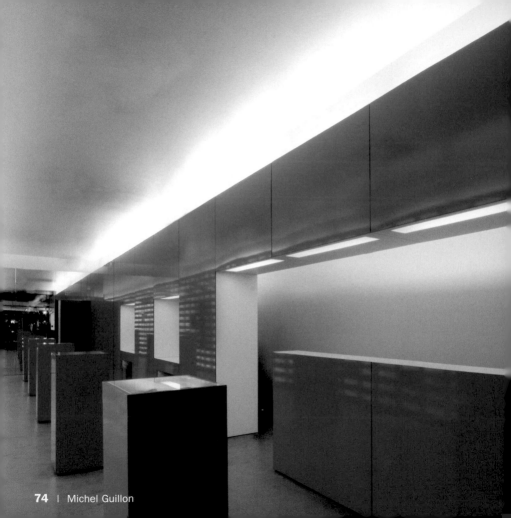

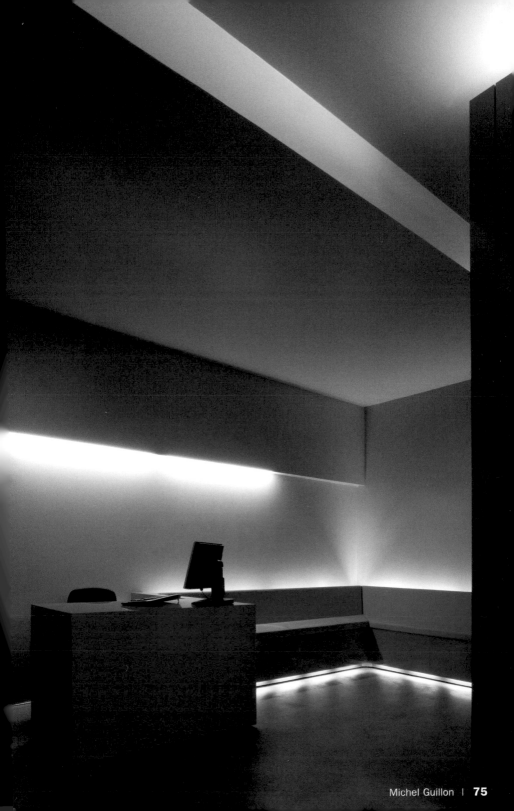

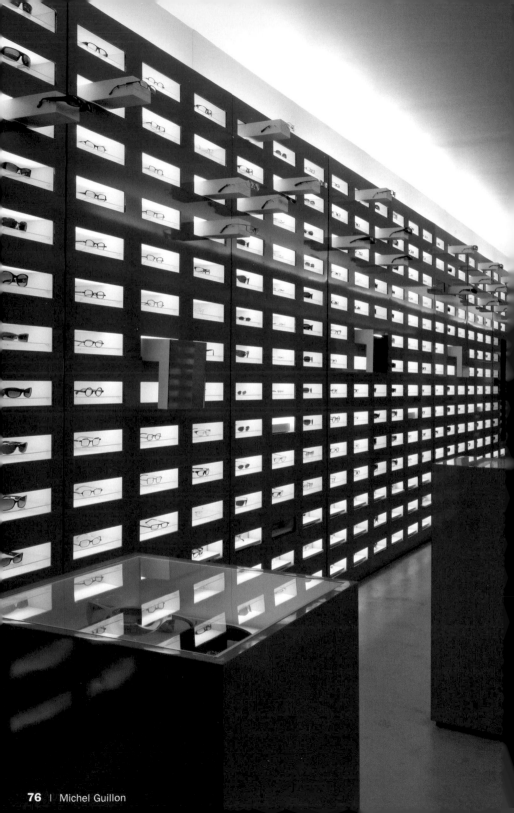

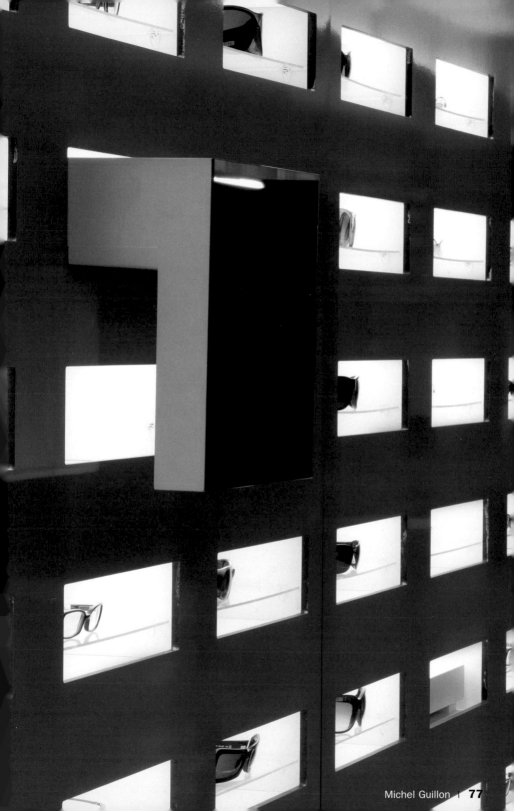

www.millerharris.com
Subway: Green Park, Bond Street
Opening hours: Mon–Sat 10 am to 6 pm
Products: Luxury perfumes
Special features: Hand engraved metal walls

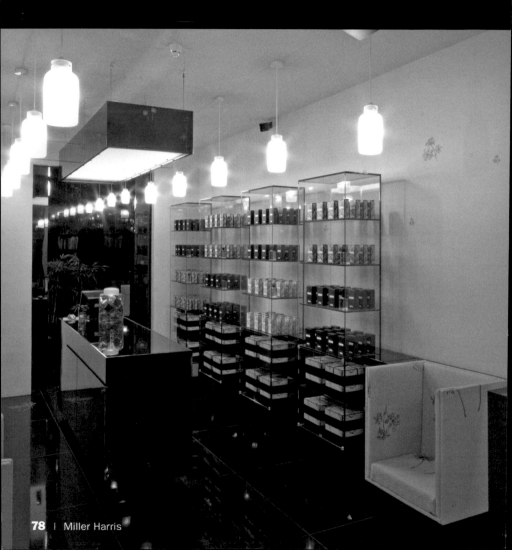

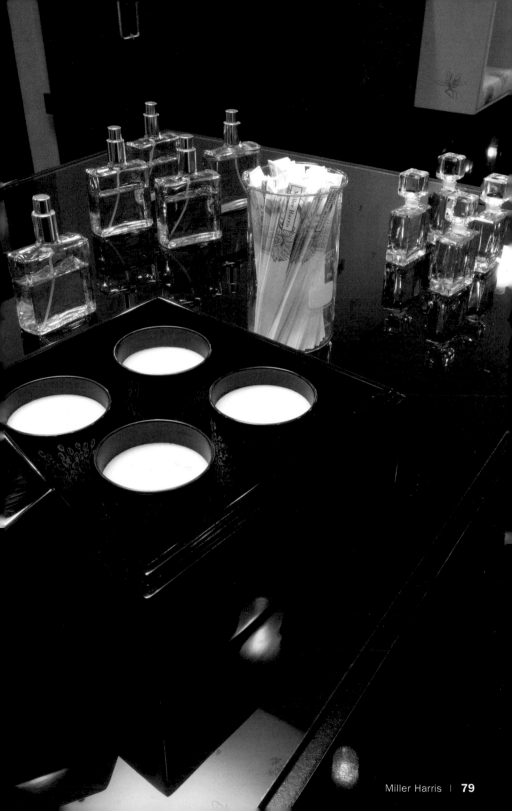

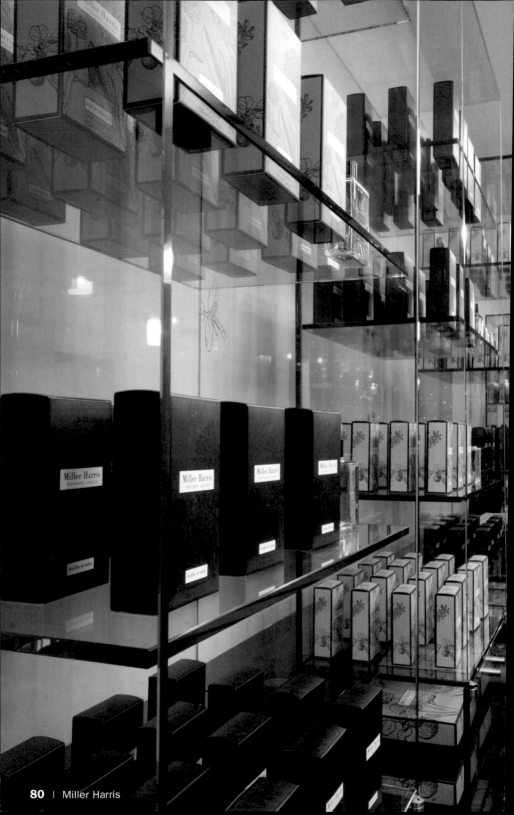

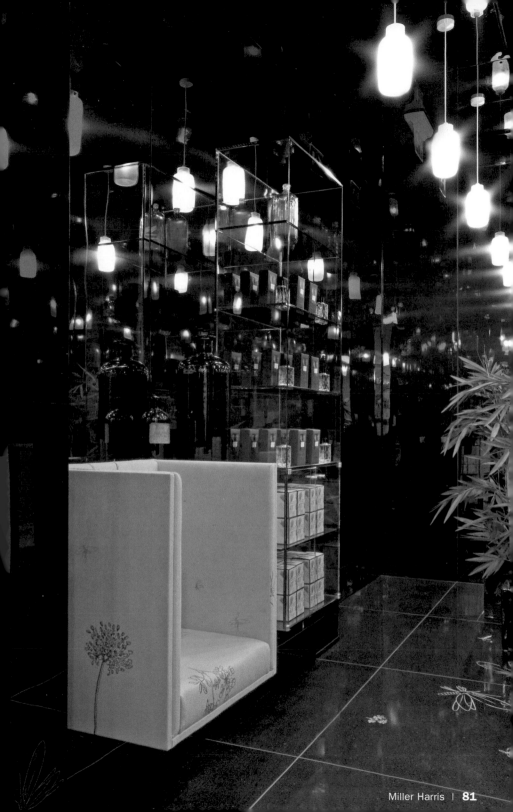

Ozwald Boateng

Design: Ozwald Boateng

9 Vigo Street I Mayfair, W1X 1AL
Phone: +44 20 7437 0620
www.ozwaldboateng.com
Subway: Piccadilly Circus, Green Park, Oxford Circus
Opening Hours: Mon–Sat 10 am to 6 pm, Thu 10 am to 7pm
Products: Men's formal wear, casual wear, luggage, accessories
Special features: Classic men's tailoring

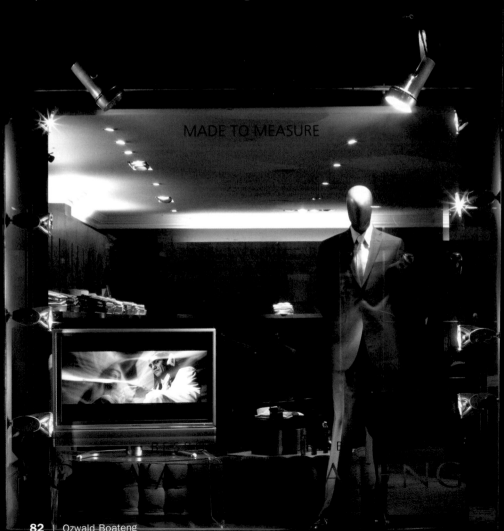

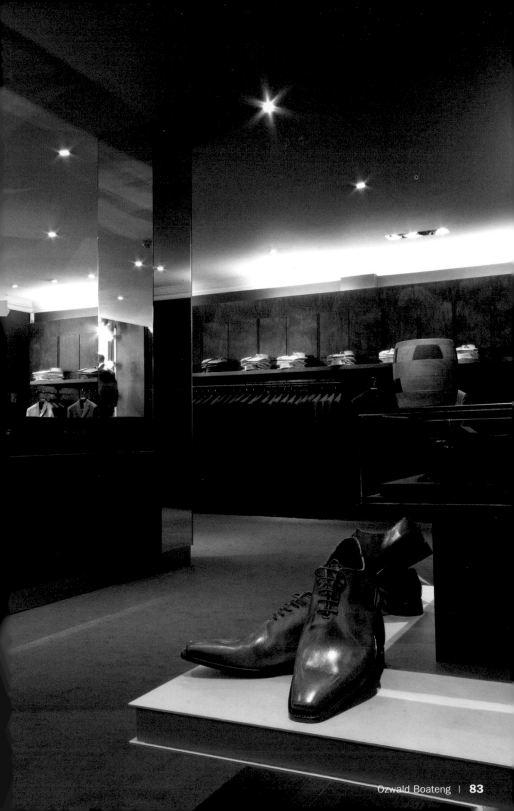

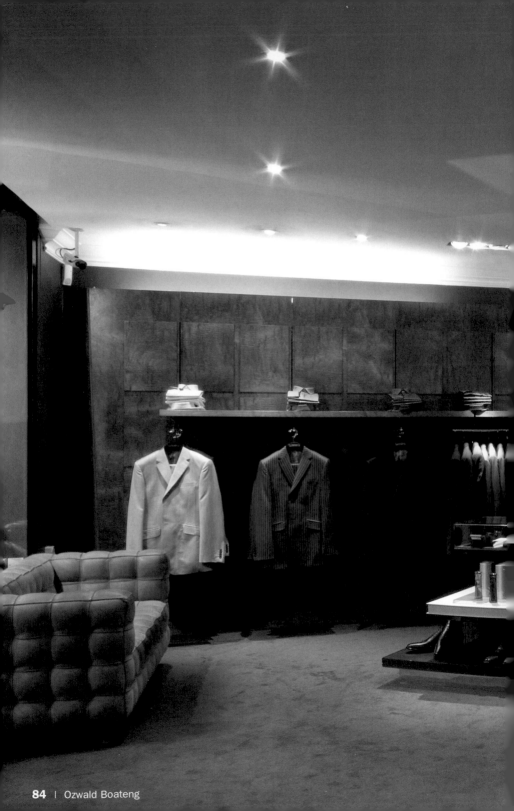

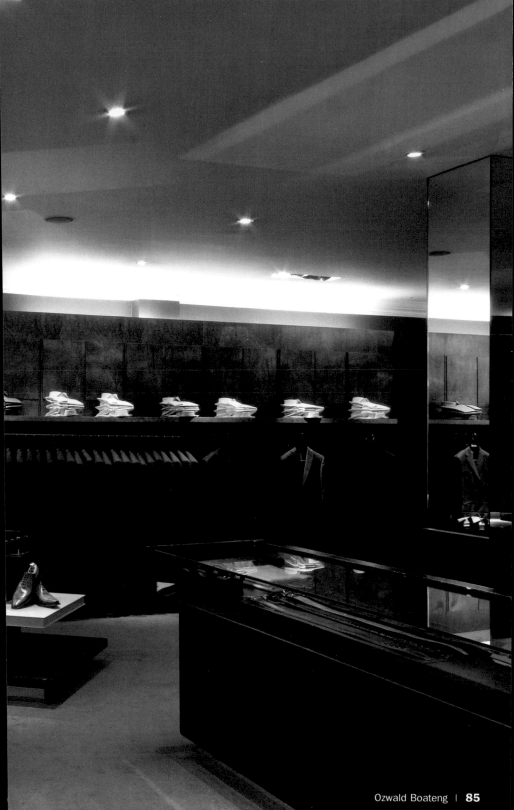

Paul Smith Westbourne House

Design: Sophie Hicks

122 Kensington Park Road | Notting Hill, W11 2EP
Phone: +44 20 7727 3553
www.paulsmith.co.uk
Subway: Notting Hill Gate
Opening hours: Mon–Thu 10:30 am to 6:30 pm, Fri 10 am to 6 pm, Sat 10 am to 6:30 pm
Products: Clothing, furniture
Special features: A shop within a house

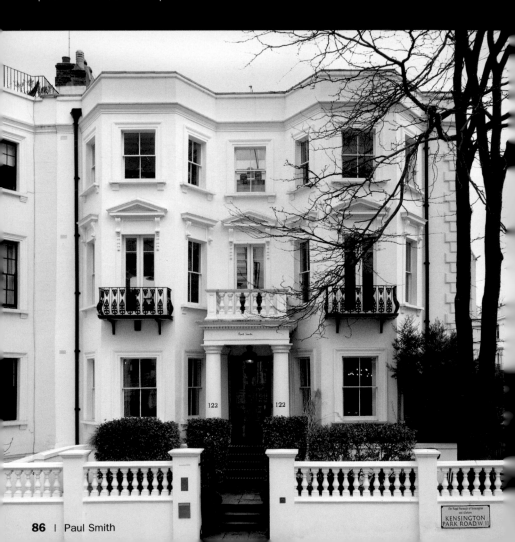

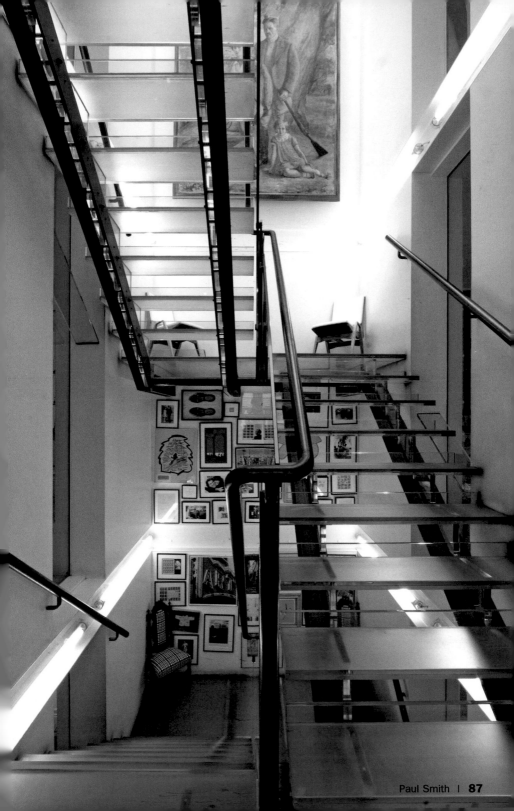

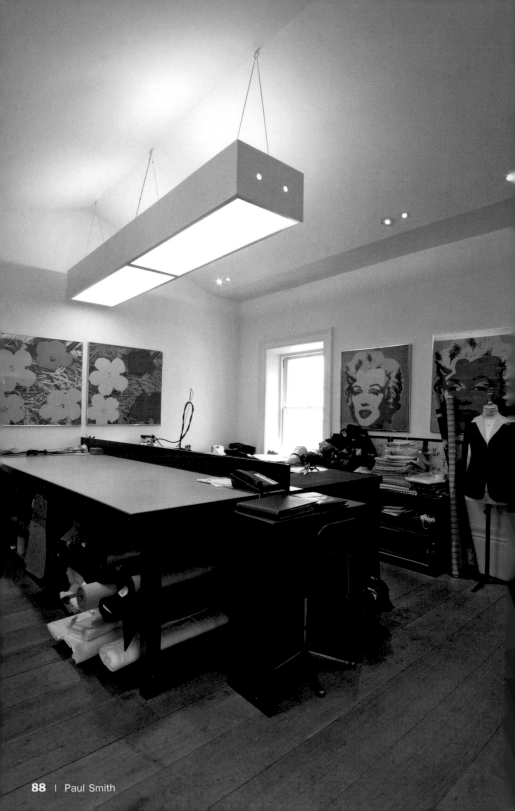

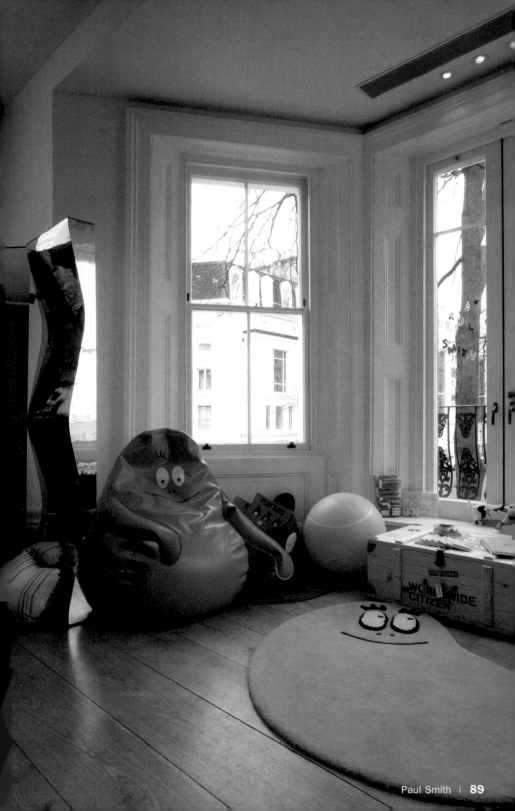

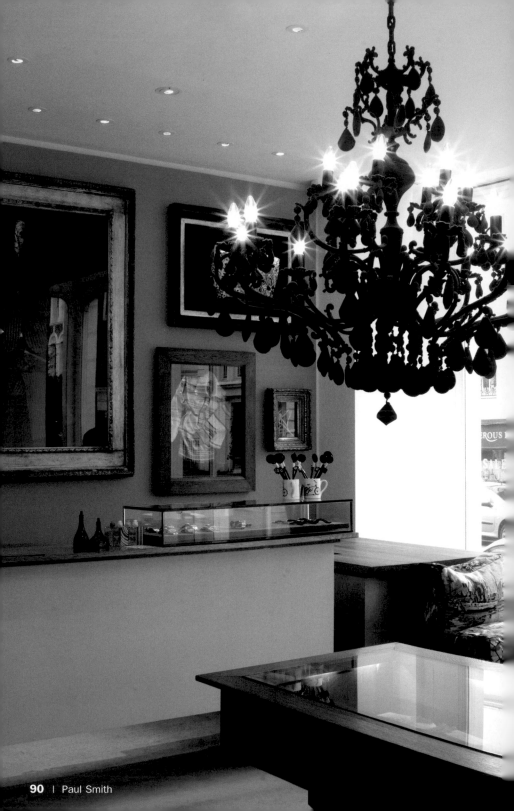

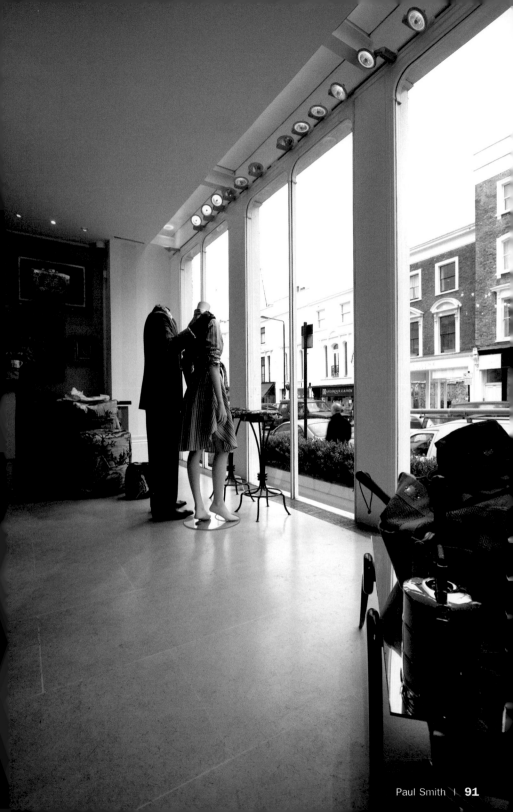

Playlounge

Design: Julie Blum / InsideOut Systems

19 Beak Street I Soho, W1P 9RF
Phone: +44 20 7287 7073
www.playlounge.co.uk
Subway: Piccadilly Circus, Oxford Circus
Opening Hours: Mon–Sat 10:30 am to 7 pm, Sun 12 noon to 5 pm
Products: Design-conscious toys, games, products, picture books, stationery
Special features: Playlounge is a space where design, art and illustration fuse with toy culture, providing an environment where everyone can play regardless of age or gender

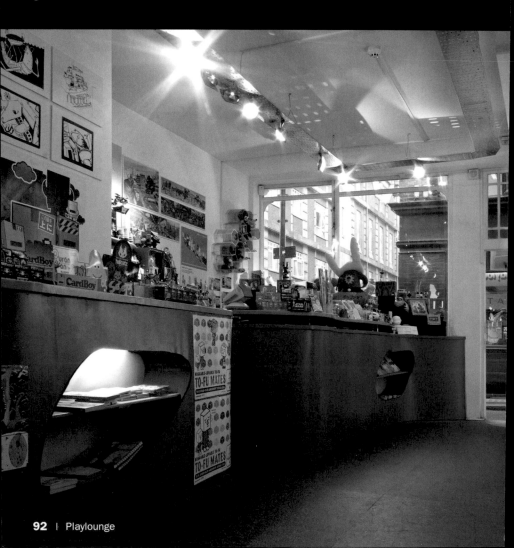

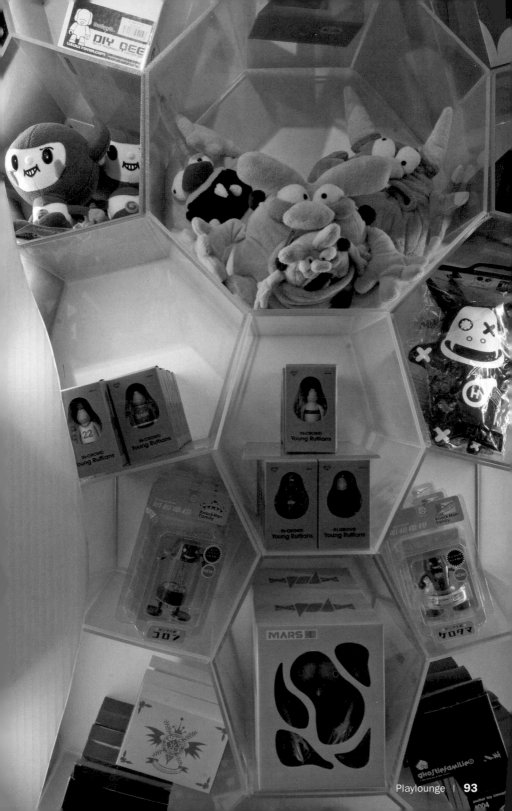

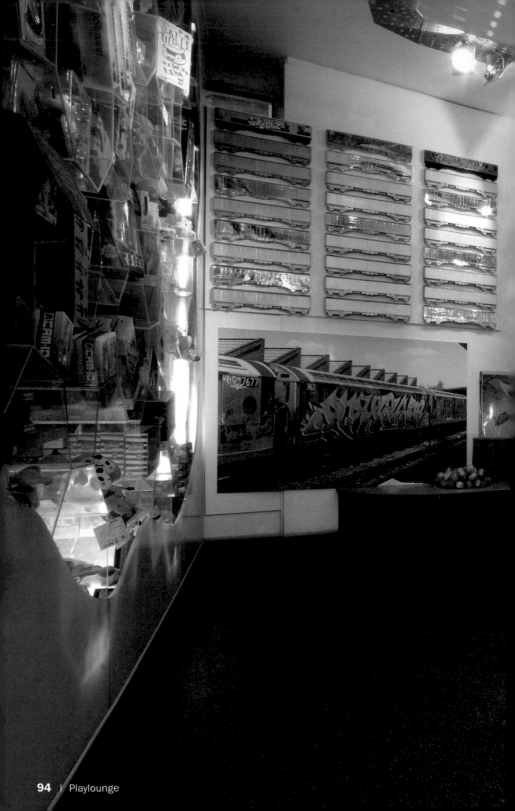

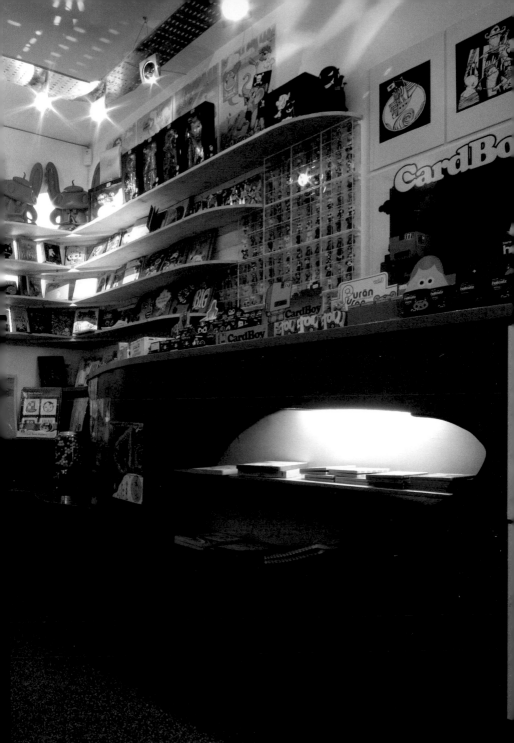

Poliform

Design: George Khachfe

278 King's Road I Chelsea, SW3 5AW
Phone: +44 20 7368 7600
www.poliform.it
Subway: Sloane Square, South Kensington
Opening hours: Mon–Sat 10 am to 6 pm
Products: Three floors of the latest Italian design, featuring beds, wardrobes, walk-in
wardrobes and Poliform's kitchen brand Varenna

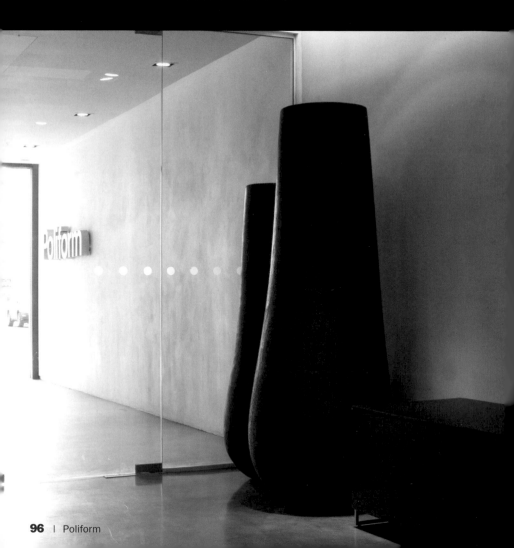

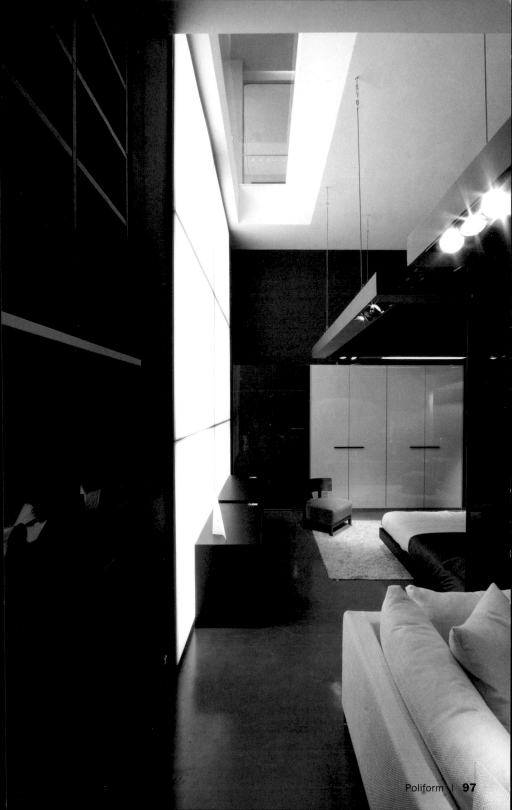

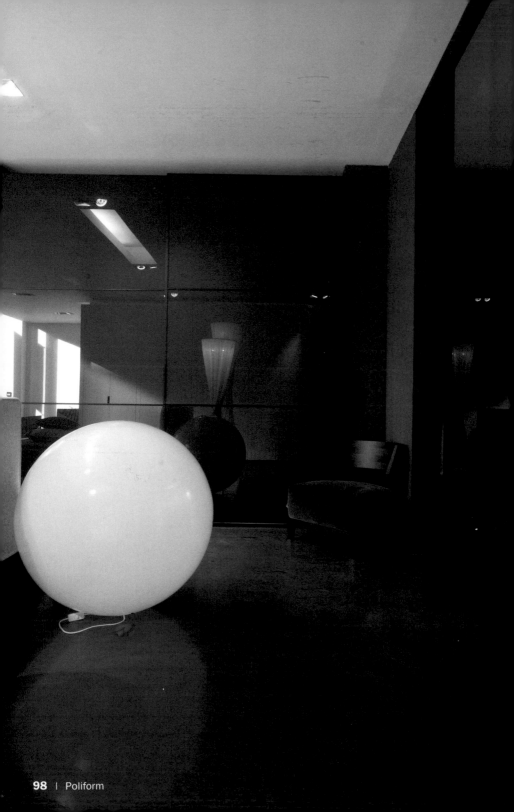

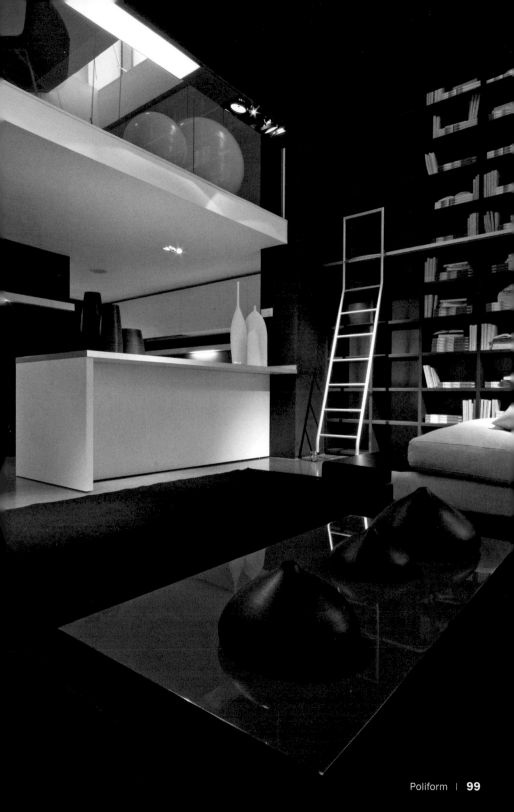

Subway: Bond Street
Opening hours: Mon–Wed 11 am to 6 pm, Thu–Sat 10 am to 7 pm, Sun 12 am to 6 pm
Products: Traditional Chinese healthcare products
Special Features: Sen brings traditional Chinese medicine to the West in an accessible way to everyone.

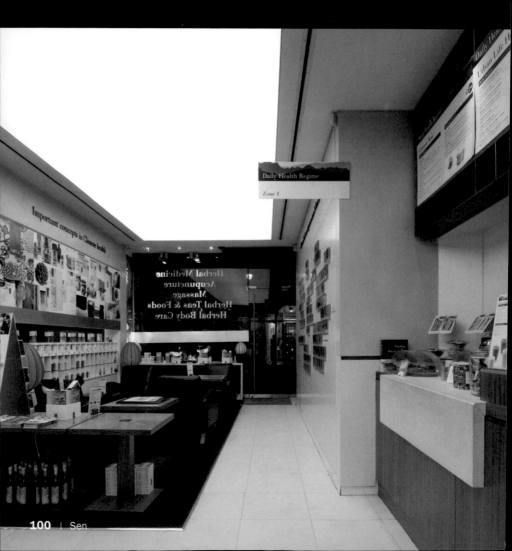

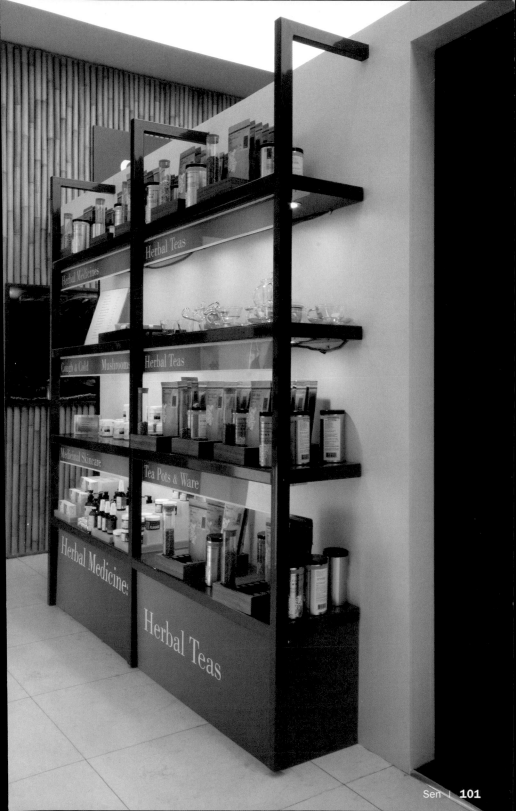

Stella McCartney

Design: Stella McCartney

30 Bruton Street | Mayfair, W1J 6LG
Phone: +44 20 7518 3100
www.stellamccartney.com
Subway: Green Park, Bond Street
Opening hours: Mon–Wed, Fri–Sat 10 am to 6 pm, Thu 10 am to 7 pm
Products: Ready-to-wear, shoes, bags, jewelry, eyewear, fragrance, bespoke tailoring
Special features: Fashion that combines sharp tailoring with humour and sexy femininity

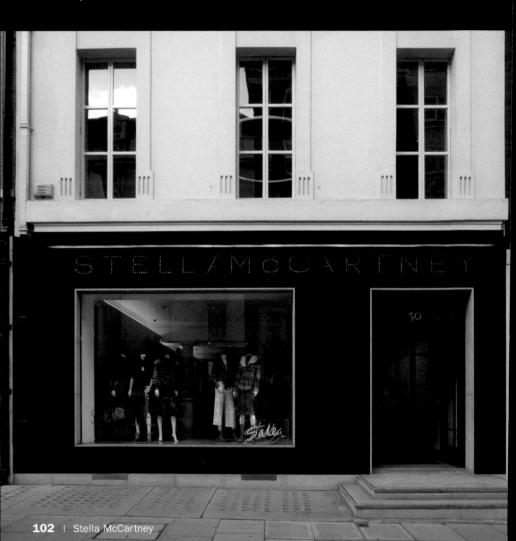

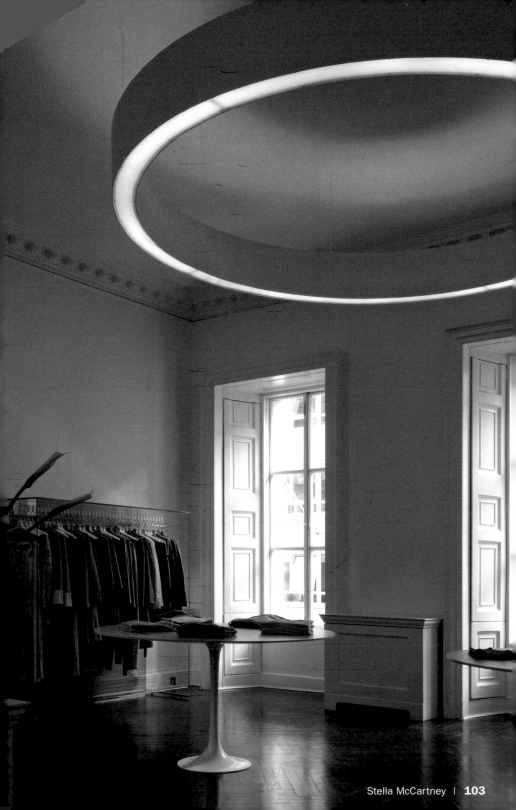

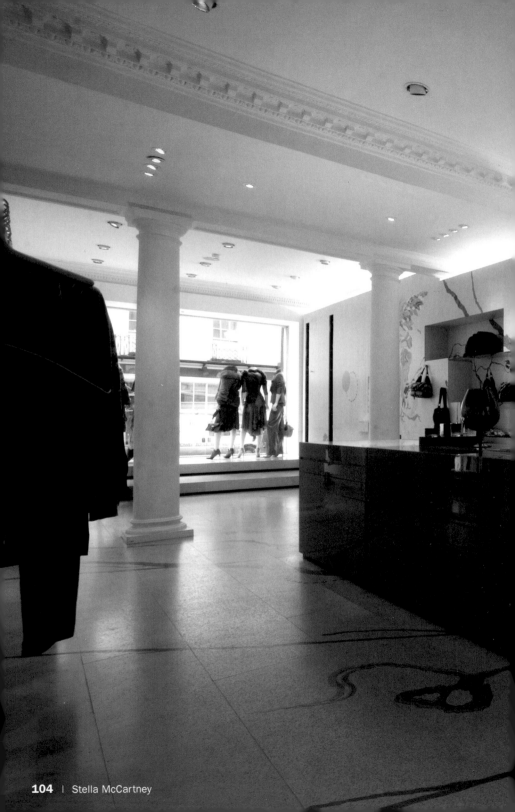

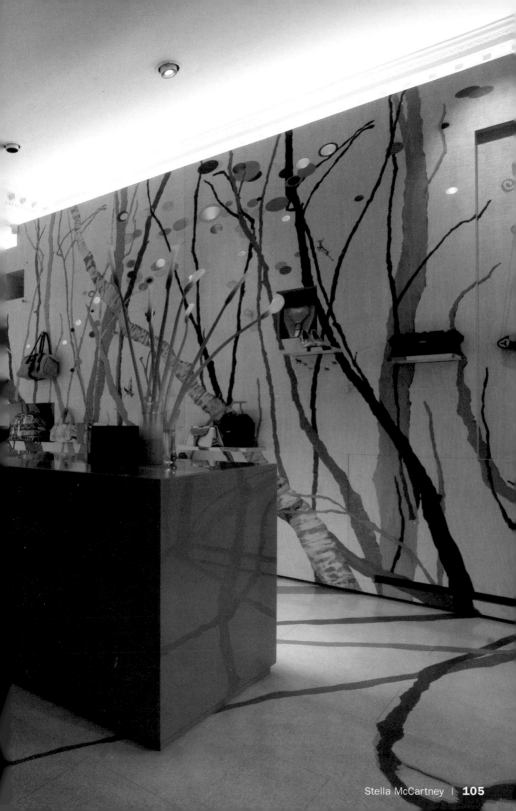

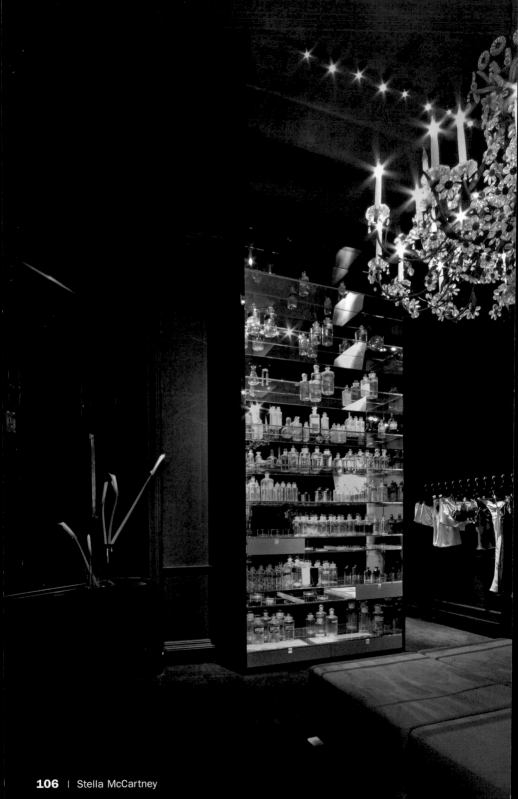

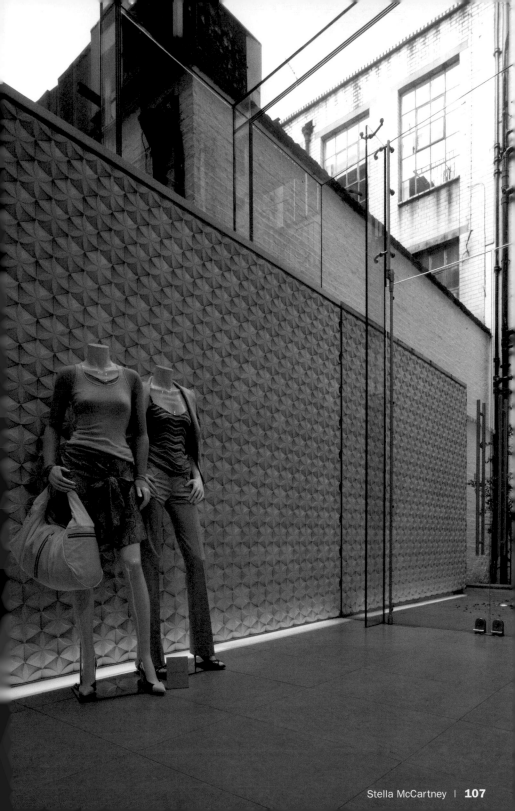

Tateossian London

Design: Robert Tateossian

15 Duke of York Square I Chelsea, SW3 4LY
Phone: +44 20 7259 0777
www.tateossian.com
Subway: Sloane Square
Opening hours: Mon–Sat 10 am to 7 pm, Sun 12 pm to 6 pm
Products: Contemporary men's and women's jewelry and accessories
Special features: Dark brown leather floor, ponyskin bar stools, white lacquer walls
with leather display boxes set in

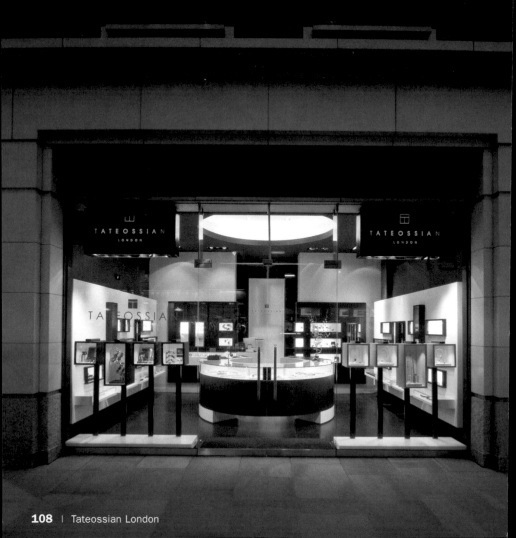

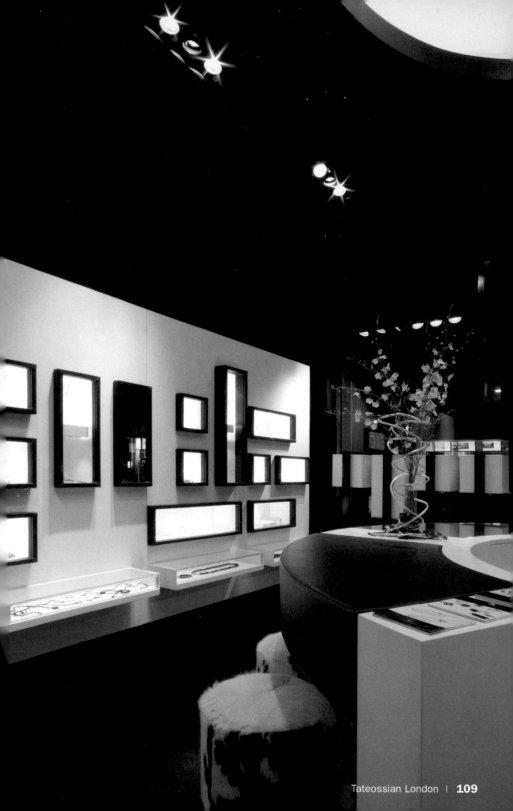

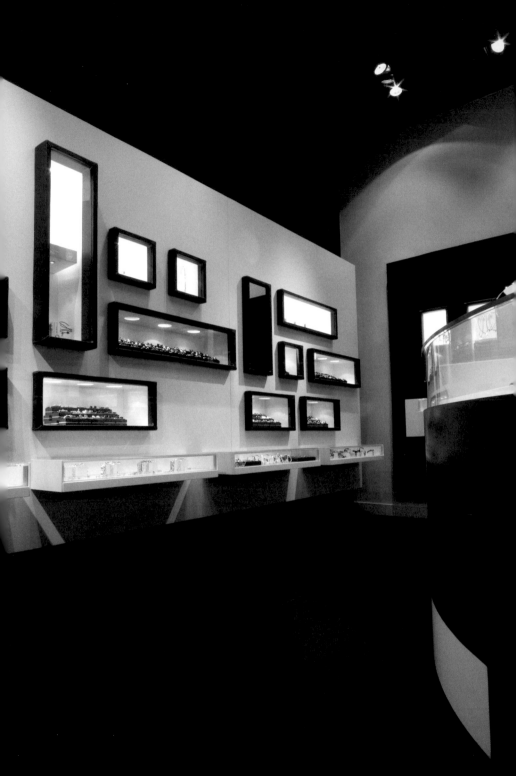

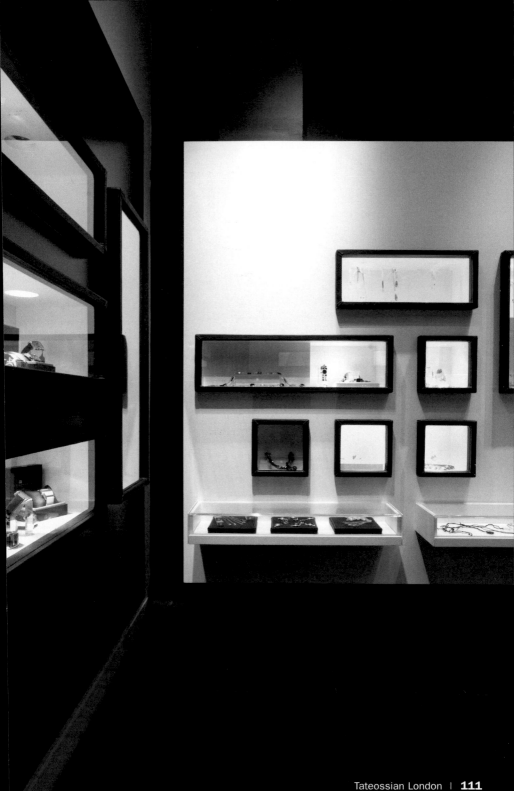

Taylor Taylor

Design: Bradley Taylor

12 Cheshire Street | Shoreditch, E2 6EH
Phone: +44 20 7033 0330
www.taylortaylorlondon.com
Subway: Shoreditch, Aldgate East, Liverpool Street
Opening hours: Mon–Thu 10 am to 8 pm, Fri 10 am to 7 pm, Sat 10 am to 6 pm
Products: Hairdressing, hair care products
Special features: Innovative ionic Japanese system for straightening hair

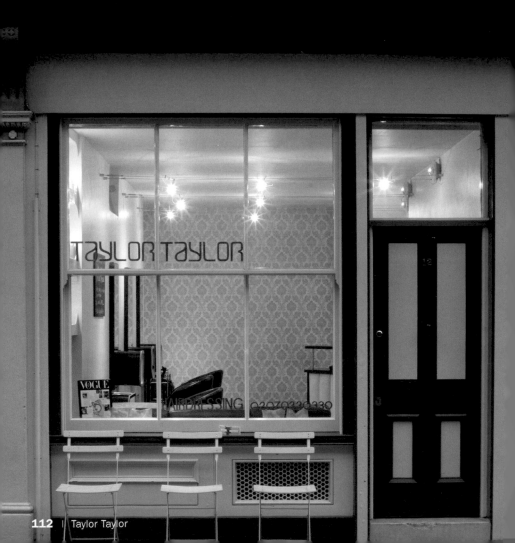

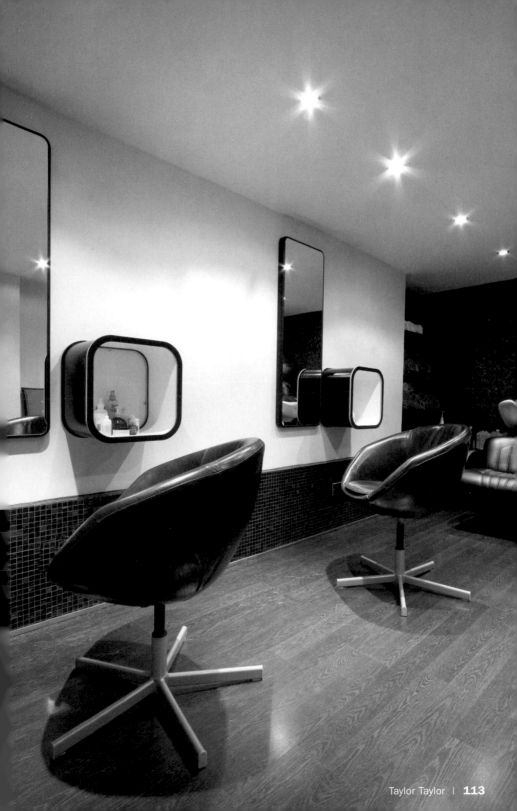

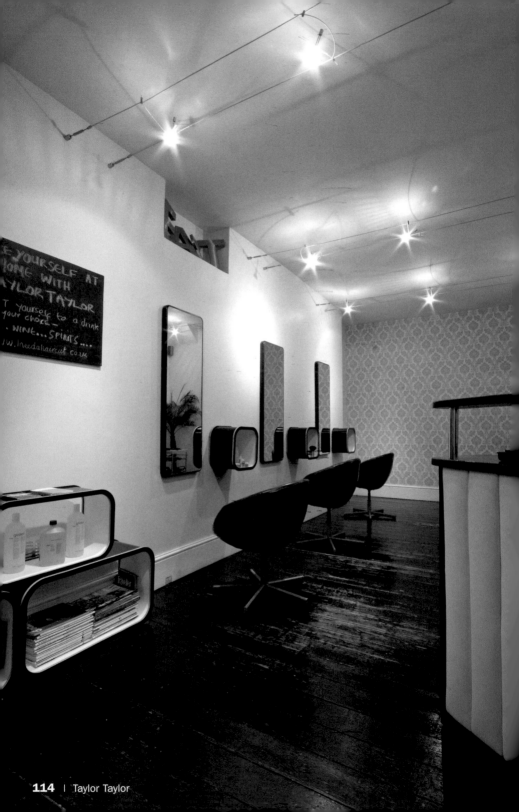

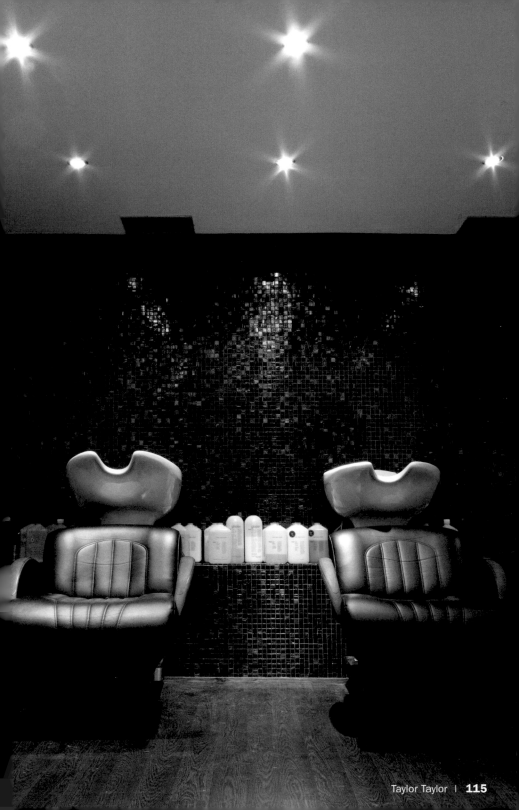

21 Warwick Street | Soho, W1B 5NE
Phone: +34 20 7437 7776
www.thegroceron.com
Subway: Piccadilly Circus, Oxford Circus
Opening hours: Mon–Fri 8 am to 11 pm, Sat 11 am to 11 pm, Sun 11 am to 4 pm
Product: Readymade meals

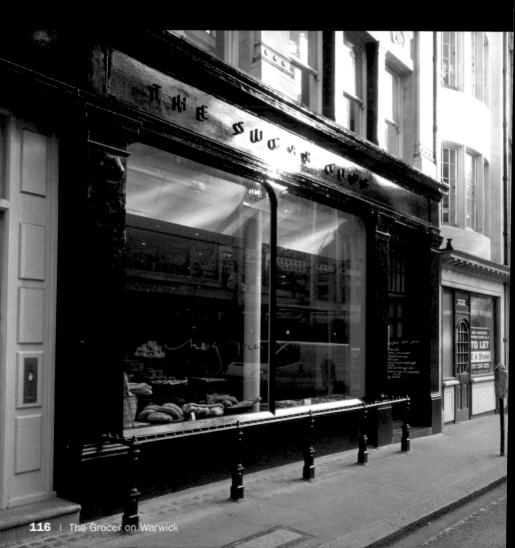

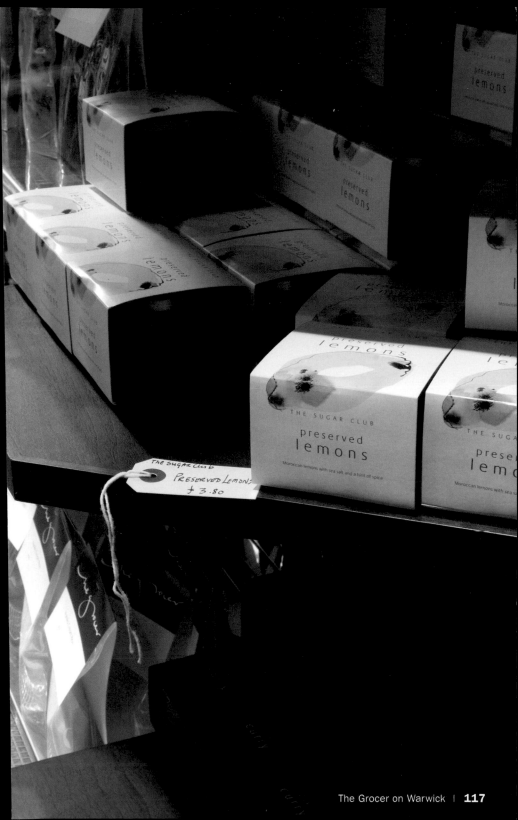

THE SUGAR CLUB
preserved
lemons
Moroccan lemons with sea salt and a hint of spice

THE SUGAR CLUB
PRESERVED LEMONS
$ 3.80

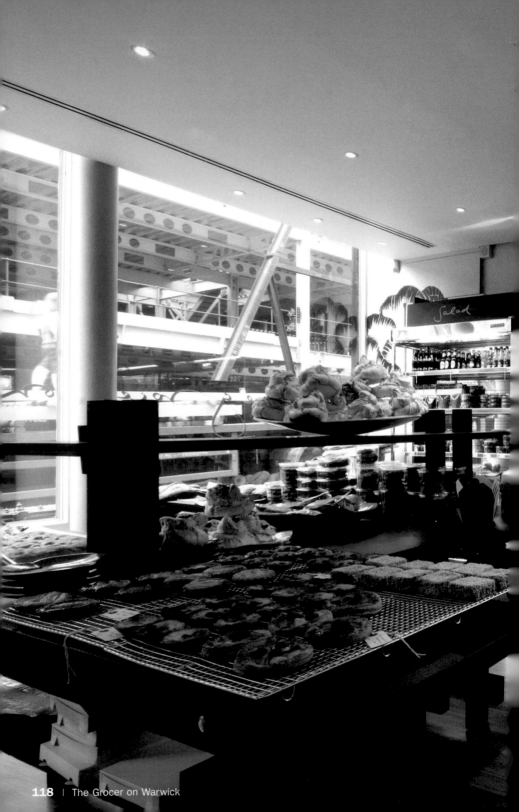

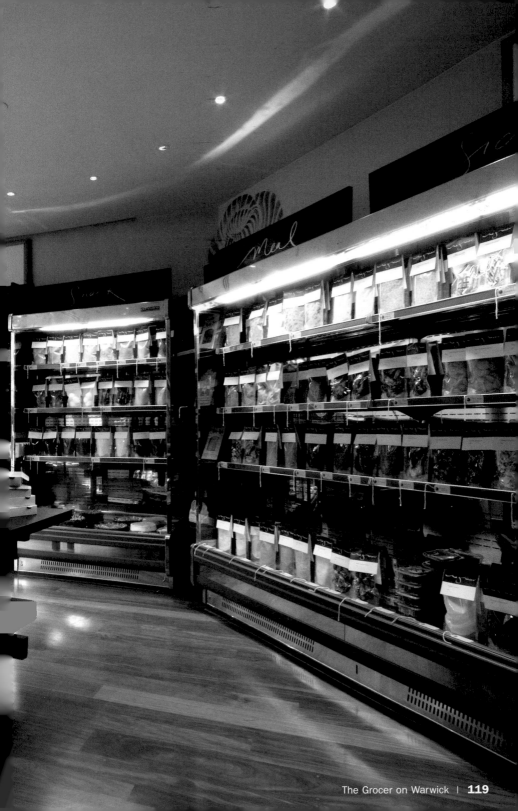

The Scooter Emporium

Design: The Scooter Emporium

10 Dray Walk, The Old Truman Brewery, 91 Brick Lane I Shoreditch, E1 6QL
Phone: +44 20 7375 2277
www.scooteremporium.com
Subway: Liverpool Street, Aldgate East, Shoreditch
Opening hours: Mon–Fri 9 am to 6 pm, Sat 10:30 am to 5 pm
Products: Classic scooters, accessories and spares
Special features: All the scooter world in a shop

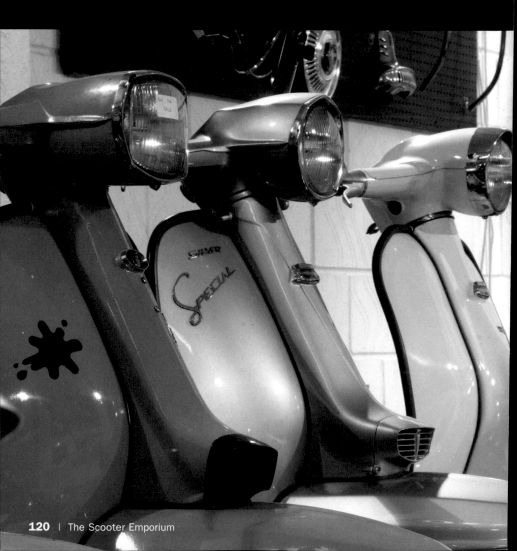

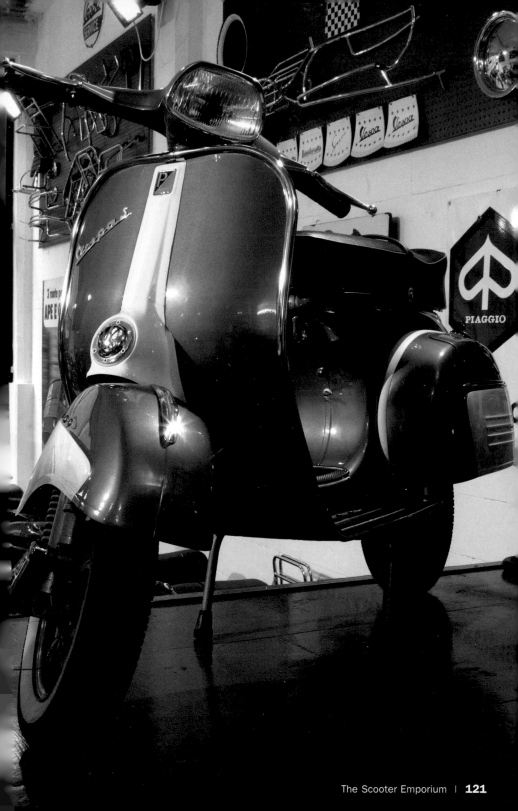

Unto this last

Design: Olivier Geoffroy

230 Brick Lane I Shoreditch, E2 7EB
Phone: +44 20 7613 0882
www.untothislast.co.uk
Subway: Shoreditch, Liverpool Street, Old Station
Opening hours: Mon–Sat 9 am to 7 pm, Sun 10 am to 6 pm
Products: Furniture and lighting
Special features: Furniture that allows ordering on-site using a digitally-controlled
machine visible at the back of the shop

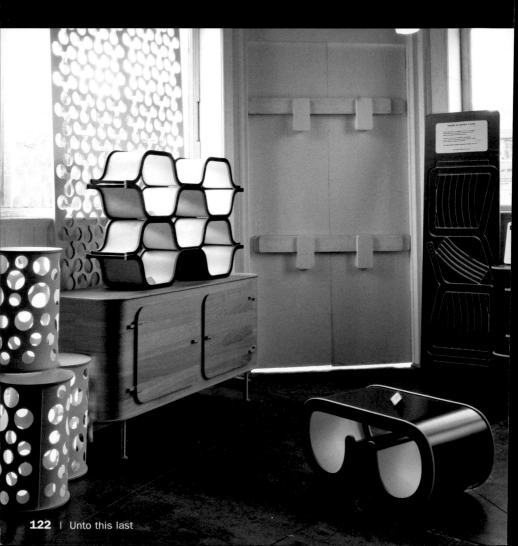

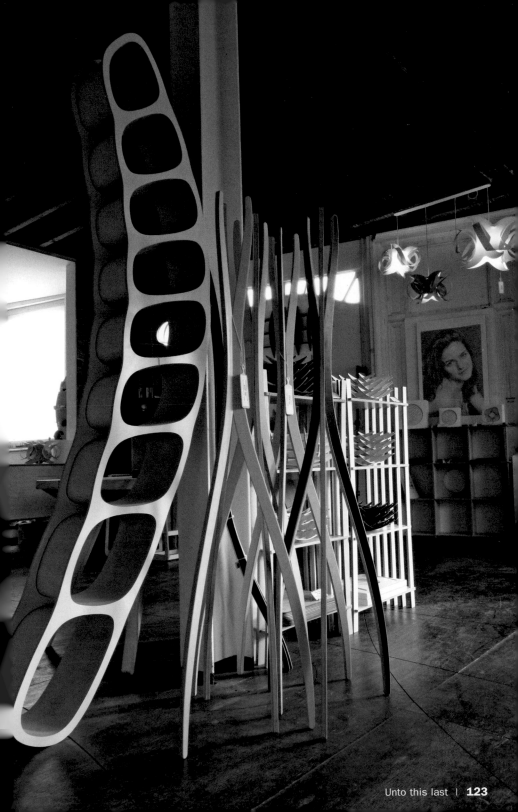

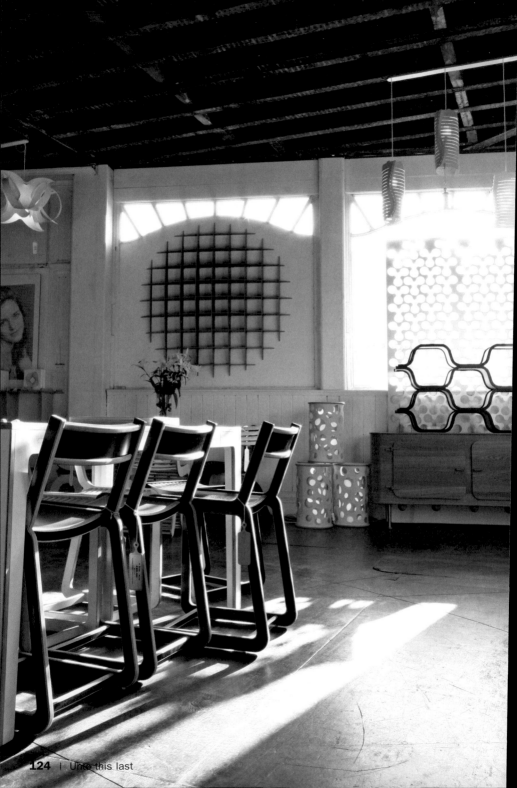

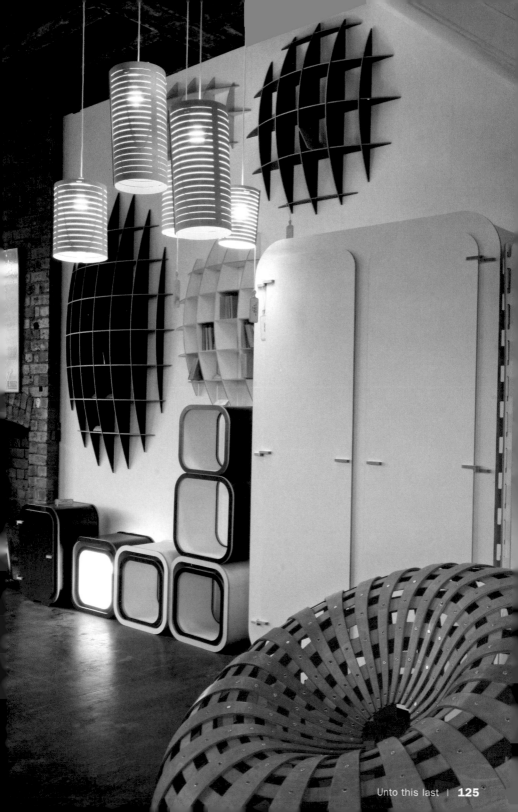

Vivienne Westwood

Design: Vivienne Westwood

44 Conduit Street | Mayfair, W1S 2YL
Phone: +44 20 7439 1109
www.viviennewestwood.com
Subway: Green Park, Oxford Circus
Opening hours: 10 am to 6 pm
Products: Clothing, accessories
Special features: As a flagship store of the brand, you can found all the different
lines, from Anglomania to the Gold Label, from the fragrance to the jewelry with the
Vivienne Westwood identity

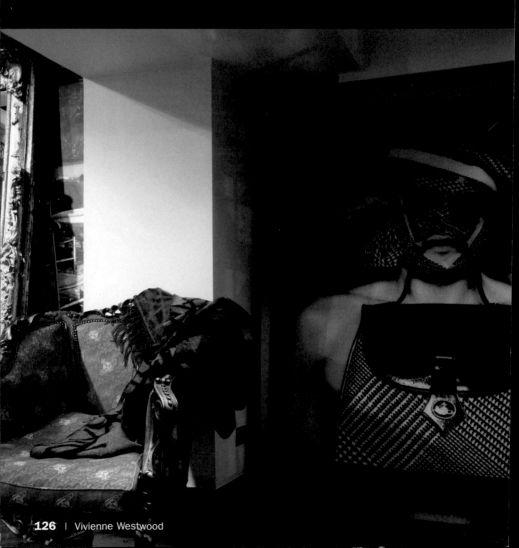

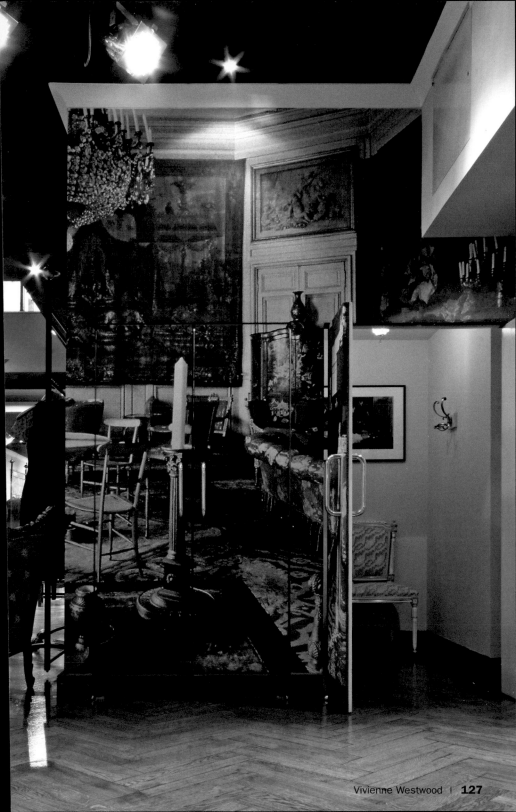

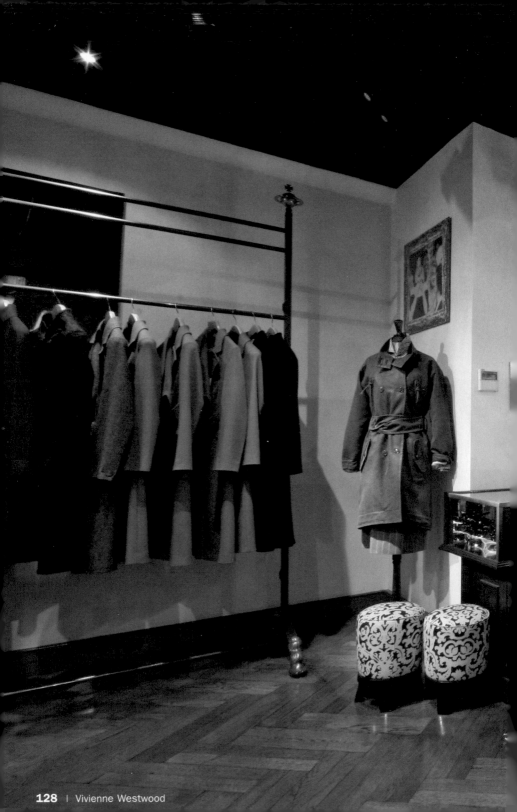

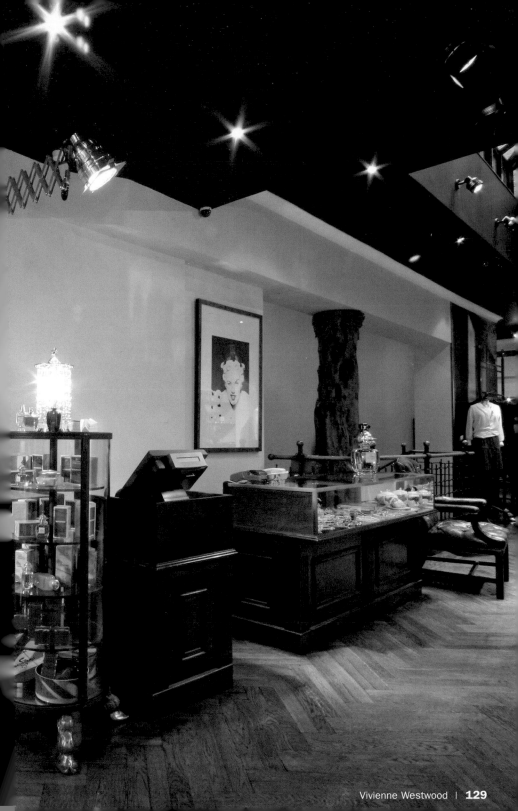

Yauatcha

Design: Christian Liaigre

15 Broadwick Street I Soho, W1F 0DL
Phone: +44 20 7494 8888
Subway: Oxford Circus
Opening hours: Mon–Sat 9 am to 11 pm, Sun 9 am to 10:30 pm
Products: French and Asian influenced patisserie, rare teas, fine ceramics
Special features: Unique boutique tea house with an exquisite range of contemporary accessories

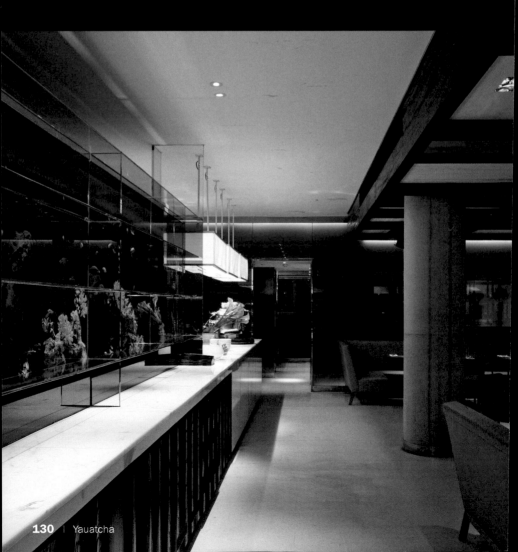

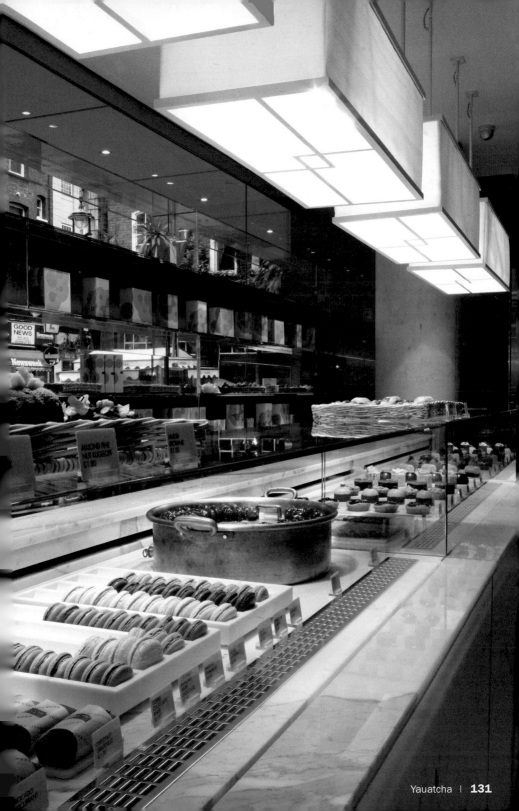

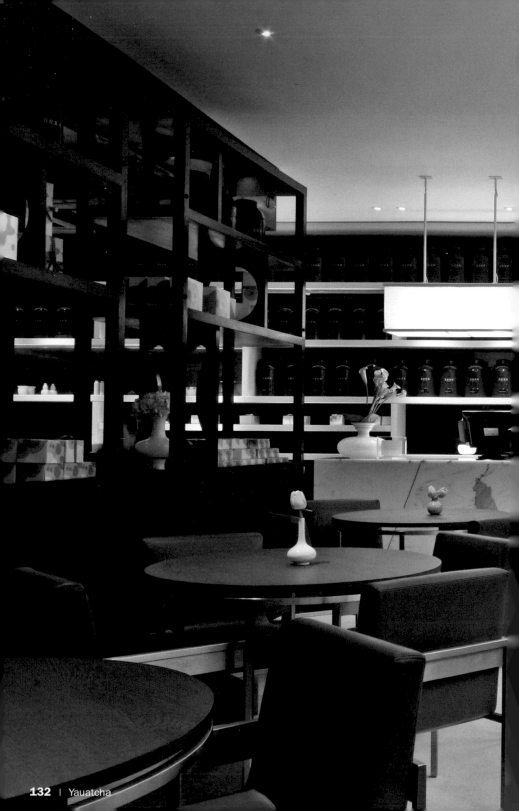

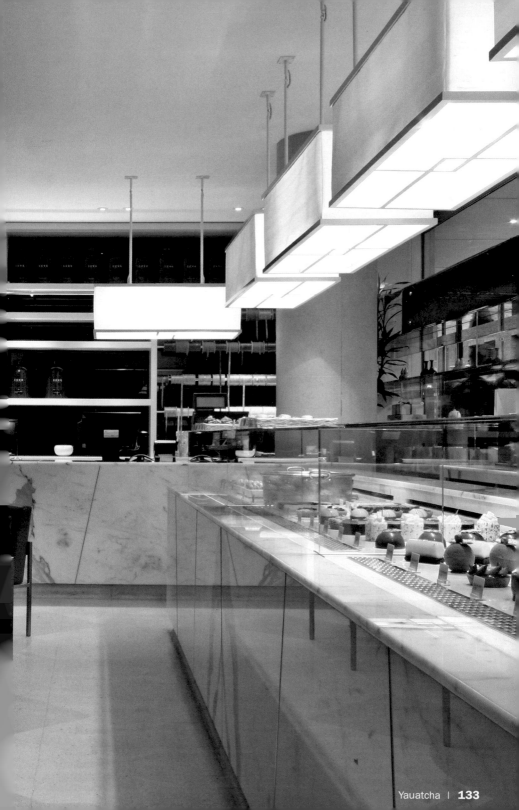

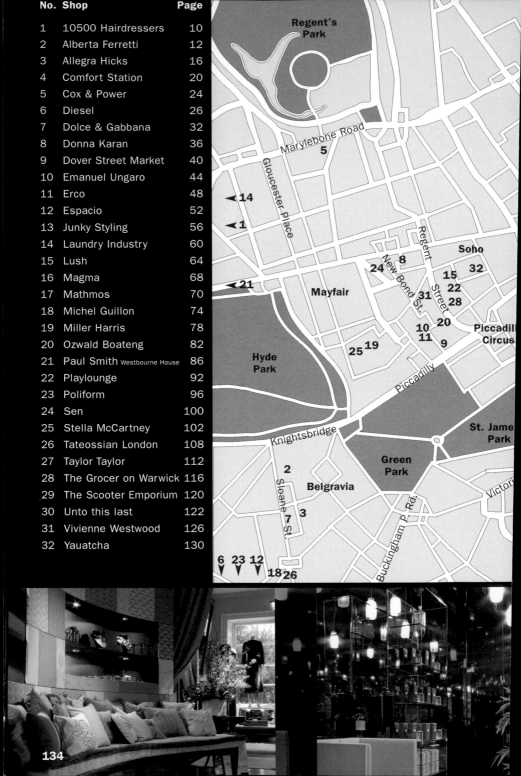

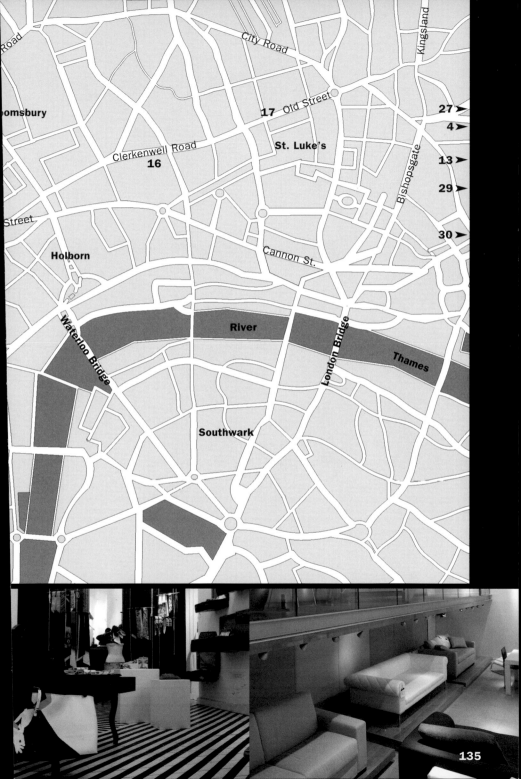

COOL SHOPS

Size: 14 x 21.5 cm / 5 1/2 x 8 1/2 in.
136 pp
Flexicover
c. 130 color photographs
Text in English, German, French,
Spanish and Italian

Other titles in the same series:

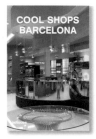

ISBN
3-8327-9073-X

ISBN
3-8327-9070-5

ISBN
3-8327-9071-3

ISBN
3-8327-9022-5

ISBN
3-8327-9072-1

ISBN
3-8327-9021-7

ISBN
3-8327-9037-3

**To be published in the
same series:**

Amsterdam
Dubai
Hamburg
Hong Kong
Madrid
Miami

San Francisco
Shanghai
Singapore
Tokyo
Vienna

teNeues